IMAGES
of America

LAFAYETTE

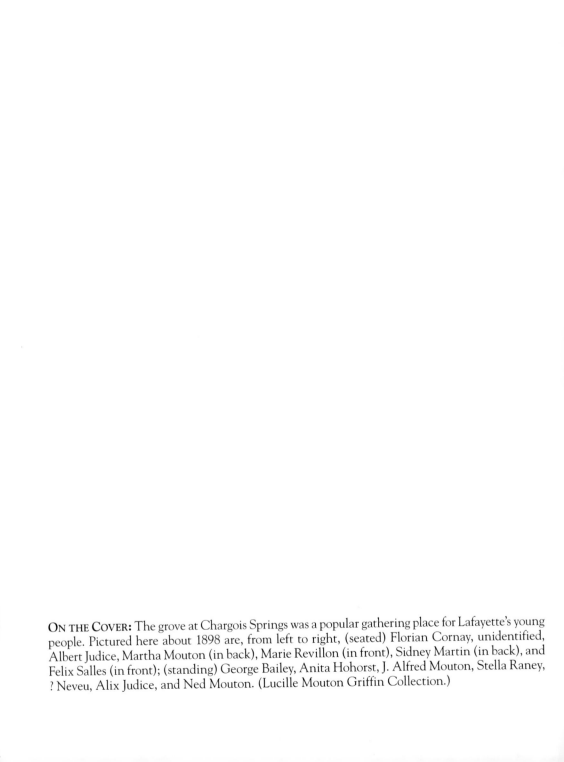

ON THE COVER: The grove at Chargois Springs was a popular gathering place for Lafayette's young people. Pictured here about 1898 are, from left to right, (seated) Florian Cornay, unidentified, Albert Judice, Martha Mouton (in back), Marie Revillon (in front), Sidney Martin (in back), and Felix Salles (in front); (standing) George Bailey, Anita Hohorst, J. Alfred Mouton, Stella Raney, ? Neveu, Alix Judice, and Ned Mouton. (Lucille Mouton Griffin Collection.)

IMAGES
of America

LAFAYETTE

Jean S. Kiesel

ARCADIA
PUBLISHING

Copyright © 2007 by Jean S. Kiesel
ISBN 978-0-7385-5261-3

Published by Arcadia Publishing
Charleston SC, Chicago IL, Portsmouth NH, San Francisco CA

Printed in the United States of America

Library of Congress Catalog Card Number: 2007922526

For all general information contact Arcadia Publishing at:
Telephone 843-853-2070
Fax 843-853-0044
E-mail sales@arcadiapublishing.com
For customer service and orders:
Toll-Free 1-888-313-2665

Visit us on the Internet at www.arcadiapublishing.com

To Alan, Leah, and Sara: You have my heart always.

CONTENTS

ACKNOWLEDGMENTS

In preparing this book, I have benefited from the assistance of a great many people. Images not otherwise credited come from the collections in the University Archives and Acadiana Manuscripts Collection in the Edith Garland Dupré Library of the University of Louisiana (UL) at Lafayette. Of particular value were the Lucille Mouton Griffin Collection, the City of Lafayette Collection, the SLII Photograph Albums, and the *Daily Advertiser* Photograph Collection. Other collections consulted include the Hannie Family Collection, the Marie J. (Mario) Mamalakis Collection, the Council for the Development of French in Louisiana Scrapbooks, the Louis F. Babin Collection, the John Edward Stephan Photograph Collection, the Bob Henderson Collection, and the La Fayette Bicentennial Celebration Collection.

Special thanks go to Denise Richter, executive editor of the *Daily Advertiser*, for permission to use photographs from that collection; P. C. Piazza, photo editor of the *Daily Advertiser*, for permission to use his photographs; Glen Pitre of Cote Blanche Productions for permission to use the image of Belizaire the Cajun; Philip Gould for permission to use the image of hurricane evacuees in the Cajundome; Kelly Strenge of the Lafayette Convention and Visitors Bureau; Anna Jane Marks of the Diocese of Lafayette Archives; Kathleen Thames and Christine Payton of UL Lafayette's Public Relations and News Services; and Lucien Martin.

Bruce Turner, head of Special Collections at the Edith Garland Dupré Library, directed me to all the best collections and corrected many errors in my text. Jane Vidrine, archives specialist, and Carole Massey, Louisiana Room assistant, have provided unlimited assistance and support. Carl Brasseaux, director of the Center for Louisiana Studies, has given me the benefit of his time and expertise. The members of the Lafayette Genealogical Society have also helped in many ways. Special thanks to Charles Patterson, who stepped in with his scanning expertise when my own poor skills failed.

Thanks to the editors at Arcadia, especially Kate Crawford, who patiently worked with me throughout the preparation of the manuscript and who answered all my questions, reasonable and otherwise.

And, most importantly, thanks to my husband, Alan, for his support, advice, and technical expertise, and to Leah and Sara, who for many months have listened to random bits of Lafayette trivia with admirable tolerance and good humor.

INTRODUCTION

At the intersections of Interstate Highways 10 and 49 sits the Hub City of Acadiana: Lafayette, Louisiana, a city of over 112,000 people, known for its celebration of Cajun culture, its leadership in the oil industry, and its developing role in technology. Its history is the subject of this book.

Who could have imagined the little village would ever achieve such greatness when it was founded nearly two centuries ago? First of all, it was named Vermilionville in 1822, for the name Lafayette belonged to a suburb of New Orleans now known as the Garden District. It was not until 1884 that the name of Vermilionville was changed to Lafayette, after the other town had been absorbed into New Orleans. Secondly, there were no roads or railroads to make the town a hub; waterways were the principal transportation routes in those days, and Vermilionville was two miles from the nearest navigable stream. Nor was there any Acadiana at that time. This term was coined by a local television station in the 1960s to describe its viewing area. The prairies of south Louisiana were generally referred to as the Attakapas region, after the colonial frontier post of Attakapas located at St. Martinville.

At first glance, it seems unlikely that little Vermilionville, situated on the prairie between the two frontier posts of Attakapas and Opelousas, would ever outstrip those older towns in population or economic importance. Historians cite four events that determined Vermilionville/Lafayette's success. First, of course, were Jean Mouton's donations of land for the Catholic Church of St. John and the Lafayette Parish Courthouse, which brought the town into being. Second was the arrival of the railroad in 1880, which helped the town escape the economic stagnation that followed the Civil War. When the railroad located its division headquarters at Lafayette, it brought well-paying jobs to the community, as well as an influx of middle-class managers with progressive ideas who helped put the town on the path to prosperity. Third was the founding of Southwestern Louisiana Industrial Institute (now the University of Louisiana at Lafayette) in 1900, which greatly improved educational and economic opportunities in the area, and fourth was the construction of the Oil Center in the 1950s, which positioned Lafayette to benefit from the growth in the offshore oil industry in the following decades.

Although they certainly were major contributing factors, these events alone do not explain Lafayette's success. After all, other towns in the Attakapas region were also parish seats and had Catholic churches much older and larger than St. John's. Those towns, located on navigable waterways, were commercial centers long before Lafayette was, and railroads ran through them as well. Not until a system of improved roads was built well into the 20th century did Lafayette become the dominant trade center for the surrounding area.

A major contributing factor lies in its citizens, who throughout its history supported myriad civic and commercial projects to help their town prosper. Following the lead set by Jean and Alexandre Mouton in the 19th century and by Maurice and Herbert Heymann in the 20th, Lafayette's citizens have supported many causes that would better their community. It was Alexandre Mouton's tireless work that convinced the railroad interests not just to route Morgan's Louisiana and Texas Railroad through Vermilionville, but also to make it the point where the lines westward and northward

connected, and then to make it the division headquarters. It took the concerted efforts of many of Lafayette's leading citizens to put together the inducements that led the Louisiana Board of Education to locate Southwestern Louisiana Industrial Institute (SLII) at Lafayette. Lafayette's development as the center of the oil industry for southwest Louisiana and the Gulf of Mexico was based on the availability of office space in the Oil Center and on the convenience of access by road and air, not on the discovery of large petroleum reserves in or near town. As the offshore oil industry expanded after World War II, Lafayette was in position to benefit.

A combination of the Arab oil embargo in the 1970s and the subsequent deregulation of the oil industry created a tremendous boom in oil production, which, because of the concentration of oil companies in the area, fueled explosive economic growth in Lafayette. At the time of the 1980 census, Lafayette was the fastest-growing metropolitan area in Louisiana and the second fastest in the South, as people flocked to take part in the oil boom. The growth in the oil sector fueled related growth in banking, construction, and real estate as well. When oil prices fell a few years later, many of those new businesses failed, unemployment rose, and population fell.

At the same time the oil industry was becoming so important to Lafayette's economy, other trends were beginning that have had a less spectacular but more lasting impact. Beginning in the 1960s, when a growing interest in Acadiana's French heritage led to the founding of the Council for the Development of French in Louisiana (CODOFIL), Cajun and Creole food, music, and traditions have been rediscovered and prized. As all things Cajun became popular nationally and even worldwide, Lafayette's tourism industry has benefited.

When the oil-based economy failed, the university focused its research efforts on helping the regional economy recover and developed a major research facility in the process. Its computer science department became one of the leading programs in the country and contributed to the growth of technology business in Lafayette.

Thus Lafayette has learned that it cannot rely on one industry to support its economy. While the oil industry remains an important contributor, the city's economy now has a much broader mix, including education, medical care, retail sales, and tourism. Technology is becoming increasingly important, as innovations such as the Louisiana Immersive Technologies Enterprise and Lafayette Utilities System's Fiber-to-the-Home project join UL Lafayette's Center for Advanced Computer Studies and the chamber of commerce's Zydetech initiative to make the city an emerging center for cutting-edge technology.

Today at the beginning of the 21st century, Lafayette is an exciting place to live, proud of its history and celebrating its unique local culture, yet enthusiastically reaching for the future.

One

THE EARLY YEARS

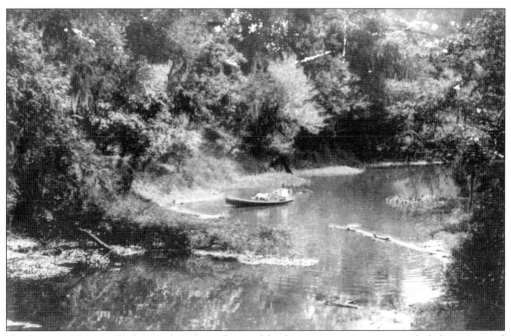

VERMILION RIVER. Before railroads and paved highways, waterways provided the principal routes for transporting goods and people. The Vermilion River was navigable as far as the Pin Hook Bridge, at least by shallow-draft vessels in times of high water. A small trading settlement, known as Pin Hook, grew up there and was briefly the seat of government for Lafayette Parish. Vermilionville was located two miles away on higher ground.

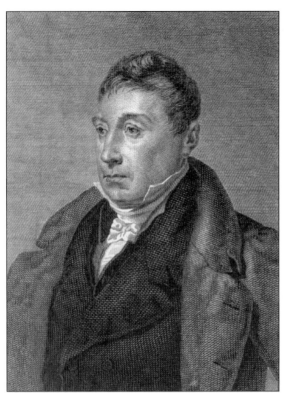

MARQUIS DE LA FAYETTE. Lafayette was named for the hero of the American Revolution, who remained immensely popular in the United States throughout his life. In 1824–1825, he toured the United States at the invitation of Pres. James Monroe and spent several days in New Orleans as a guest of the city. Lafayette Parish, created in 1823 as enthusiasm was building for the Marquis's impending visit, was named in his honor.

GRAVE OF JEAN MOUTON. The son of Acadian exiles, Jean Mouton came to the Attakapas region about 1780, where he prospered growing cotton and raised a large family. He donated land for the Catholic Church of St. John the Evangelist and the Lafayette Parish Courthouse, around which he laid out the town of Vermilionville. He and his wife, Marie Martha Bordat, are buried in St. John's Cemetery behind his church.

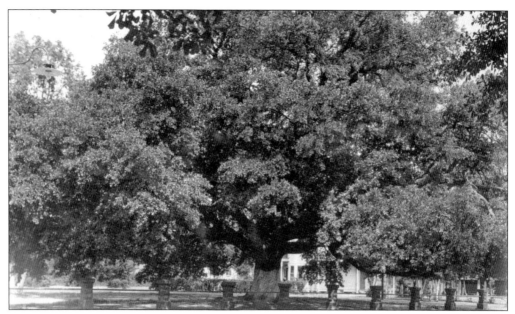

ST. JOHN'S OAK. Jean Mouton chose to locate St. John's Church near this majestic oak tree, later also known as the Cathedral Oak. Today it is estimated to be 500 years old and has a trunk girth of more than 28 feet and a limb span of 145 feet. This photograph was taken in 1927, when it was the style to whitewash the trunks of live oaks.

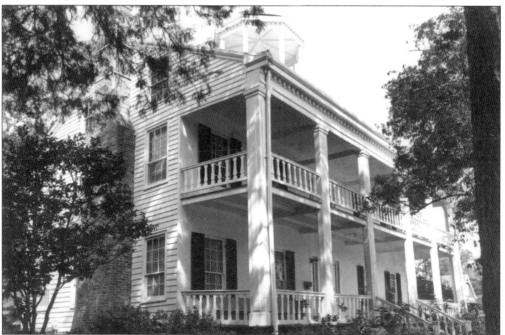

MOUTON TOWN HOUSE. This house was originally a one-room Sunday house used by Jean Mouton's family. Alexandre Mouton added three rooms in the 1820s when it was his home and law office. The house passed through a series of owners, including Dr. W. G. Mills, who added the second story and cupola in 1849. Les Vingt Quatre, a women's civic organization, restored the property and established the Lafayette Museum in 1955.

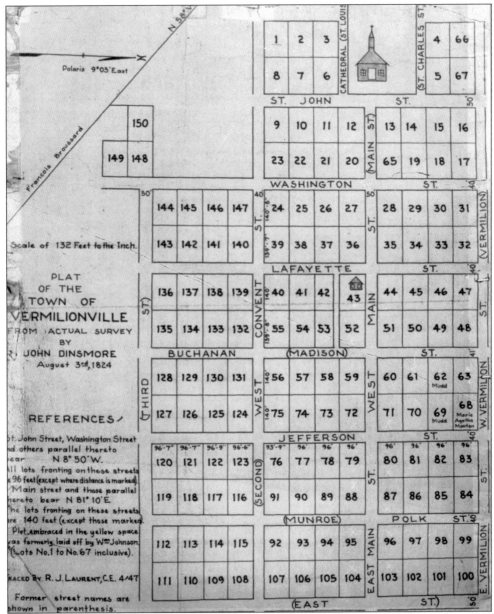

PLAT OF VERMILIONVILLE. Jean Mouton laid out his town in a simple grid oriented to the points of the compass. The building he donated for the first courthouse stood on lot 43. When the second courthouse was built in 1835, Main Street was split into North and South Main with the Courthouse Square in the middle, so the courthouse and the church faced each other. In the beginning, most businesses were located near the church or the courthouse or between the two. Lee Avenue later cut diagonally across the southeastern part of the map, and the cross streets and lot lines were reoriented to that axis. What remains of Third Street is now Barry Street, and East Street is now a portion of Taylor Street. After the railroad tracks were laid northeast of town, streets in new additions were laid out to run parallel or perpendicular to the tracks. Today many people find the streets in the downtown area confusing because they are not oriented to the rest of the city.

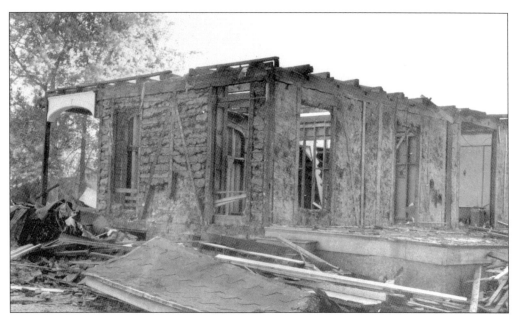

BOUSILLAGE. The Acadians who first settled the area around Vermilionville built their houses out of bousillage, a mixture of Spanish moss and mud laid in double handfuls across sticks placed between the uprights of the building frame. The resulting walls were very sturdy and kept the home cool in the summer and warm in the winter. Shown here is an old bousillage-walled house as it was being dismantled.

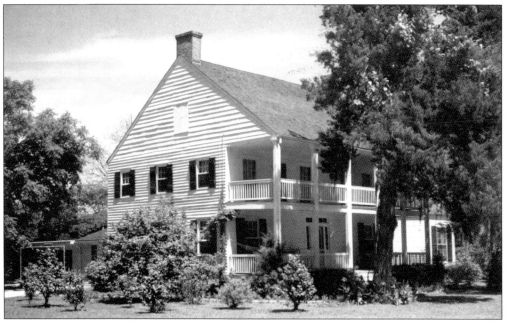

VERMILIONVILLE INN. When this house was constructed is not known, but it is mentioned in a land sale from Sarah Cotton to Henry Monnier in 1853. Because it was occupied by Gen. C. C. Washburn during the Federal invasion, it was not burned as were neighboring plantation houses. It was later owned by Dr. P. M. Girard, then by Maurice Heymann, who operated a nursery near there. It now houses Café Vermilionville.

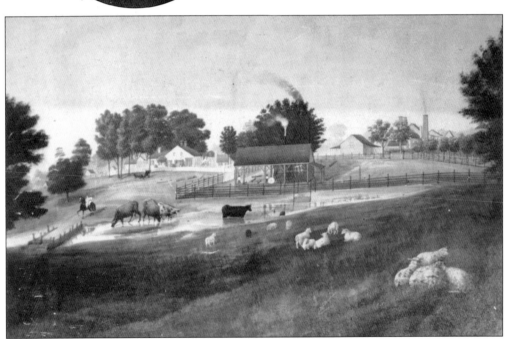

DR. AND MRS. MATTHEW CREIGHTON. Natives of Kent County, Maryland, Dr. Matthew Creighton and his wife, Polly Turpin Jacobs, settled near Vermilionville about 1811. He was probably the first medical doctor in the area, and he continued to practice medicine for nearly 40 years. His home and office were at his plantation on the east bank of the Vermilion River near the Pin Hook Bridge, about two miles from town.

MAGNOLIA PLANTATION. Just east of Vermilionville lay Magnolia Plantation, the home of Andre Valerien Martin. It was one of the largest sugar plantations in Lafayette Parish in the decades before the Civil War. New Orleans landscape artist Adrien Persac painted the plantation in 1860. The land later passed to the Diocese of Lafayette, which built De La Salle School, Immaculata Seminary, and the Carmelite Monastery there.

ALEXANDRE MOUTON. A planter, politician, and business leader, Alexandre Mouton worked throughout his life to help Vermilionville develop. His political career included terms as U.S. senator and governor of Louisiana, president of the Lafayette Vigilance Committee, and president of the Louisiana secession convention. His sugar plantation, Ile Copal, was by far the largest in Lafayette Parish. Late in his life, he led efforts to bring the railroad to Vermilionville.

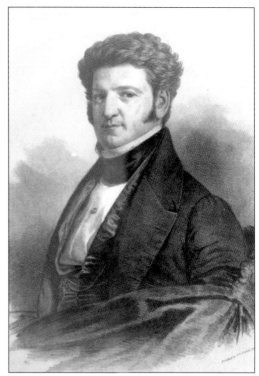

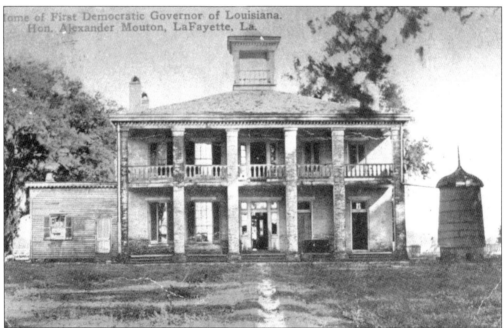

ILE COPAL. Governor Mouton resided at Ile Copal, his sugar plantation on the outskirts of Vermilionville. With over 20,000 acres and 120 slaves, it was by far the largest plantation in Lafayette Parish. The large brick house had four rooms on each floor, with a wide center hall. The lane leading from the house to town was lined with oak trees and was later named Oak Avenue (now Jefferson Street).

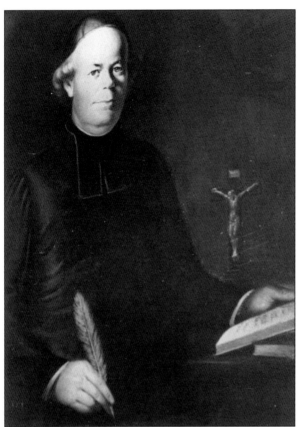

PÈRE MÉGRET. Antoine Désiré Mégret was named pastor of the church in Vermilionville in 1842. A man of great energy, he fought the trustees over control of the church, built a new church building, brought in the Sisters of Mount Carmel to open Mount Carmel Academy, and founded the church of St. Mary Magdelen and the town of Abbeville in Vermilion Parish before his death of yellow fever in 1853.

ST. JOHN'S CHURCH. In 1821, Jean Mouton donated land to the Catholic Church for a church building, thus laying the foundation for the town that became Lafayette. The building shown here was constructed in the early 1850s by Fr. Antoine Désiré Mégret. During the Civil War, Vermilionville was occupied by Federal forces, and the balcony around the church steeple, visible for miles over the prairie, was used by the Signal Corps.

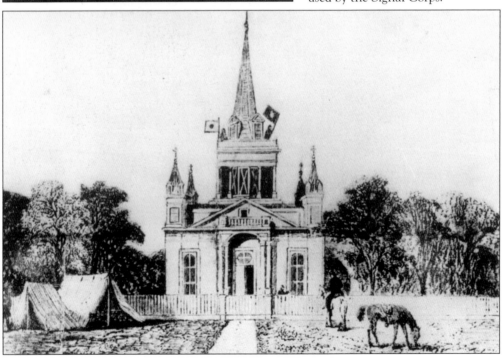

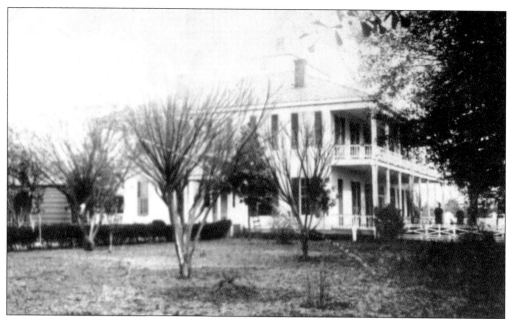

MOUNT CARMEL ACADEMY. In 1846, Father Mégret invited the Sisters of Mount Carmel to open a girls' school in Vermilionville. This frame structure on Lafayette Street near Convent Street was built in 1873 and was replaced by a brick building in 1924. The school continued in operation until 1967, when it merged with Cathedral High School for boys. The campus was sold in 1980 and now houses First Baptist Church Christian School.

CHARGOIS HOUSE. Built in the early 1850s by Richard Chargois, one of the first brick makers in Vermilionville, this house originally stood at 514 Buchanan Street. Constructed of hand-hewn cypress and bricks made by Chargois himself, the house was warm in the winter and cool in the summer. In 1967, it was moved to the outskirts of Lafayette and restored by J. C. Chargois Jr., a great-grandson of the builder.

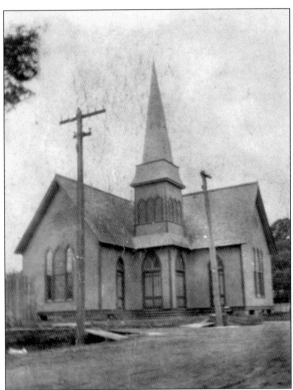

METHODIST CHURCH. Circuit riders visited Vermilionville beginning in the 1830s, and in 1858, Benjamin Porter Paxton donated a piece of land on the corner of Washington and Congress Streets for this church. In 1925, the congregation moved to their present building on the corner of Lee Avenue and Main Street, bringing with them the pulpit and other furnishings from the old church, many of which are still in use today.

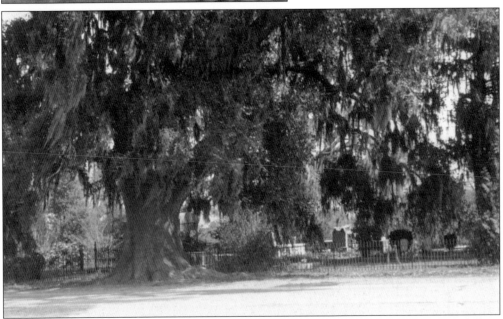

PROTESTANT CEMETERY. The Lafayette Protestant Burial Ground Association was organized about 1880, but the cemetery itself is much older. The oldest tombstone marks the grave of James Greig, who died in 1833, when the site was a mile outside of town on the road between Vermilionville and Pin Hook. Today the site is well inside the city limits, at the corner of Pinhook Road and University Avenue.

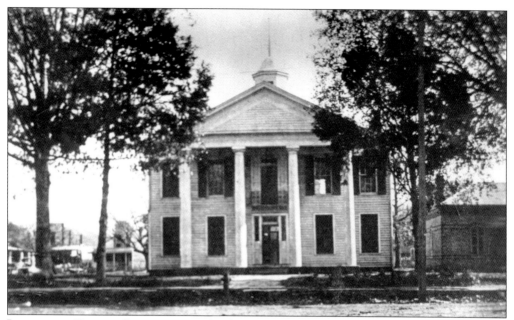

LAFAYETTE PARISH COURTHOUSE. At the request of Jean Mouton who donated the land, the courthouse was located two blocks from the Catholic church. This is the third structure to serve as the courthouse. Built in 1860 at a cost of $8,900, it continued to house the parish court and government agencies until replaced in 1927. The smaller building to the right was the recorder's office.

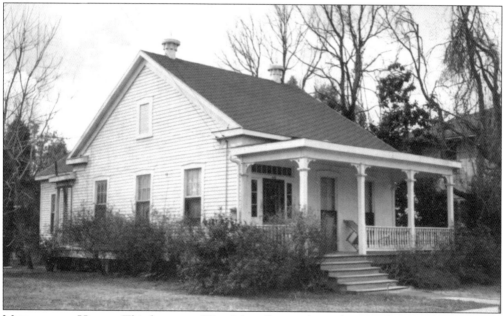

MISSIONNIER HOUSE. This house on West Main Street, shown here in the 1950s, was the site of a brutal murder a century earlier. A widow, Lise Missionnier, was murdered by her slaves and her body thrown down the well. The crowd that formed to search for her and to identify the perpetrators demonstrated the effectiveness of vigilante justice, leading to the organization of a Committee of Vigilance a few months later.

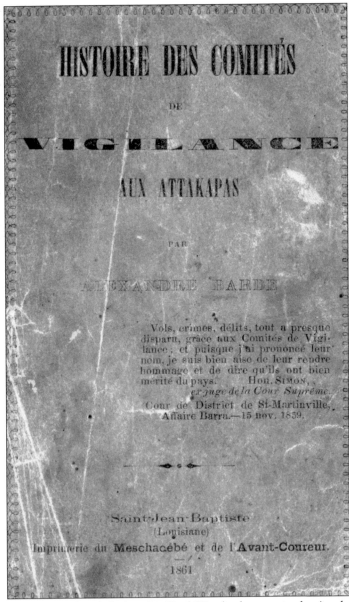

HISTOIRE DES COMITÉS
DE
VIGILANCE
AUX ATTAKAPAS

PAR

ALEXANDRE BARDE

Vols, crimes, délits, tout a presque
disparu, grâce aux Comités de Vigi-
lance ; et puisque j'ai prononcé leur
nom, je suis bien aise de leur rendre
hommage et de dire qu'ils ont bien
mérité du pays. Hon. SIMON,
ex-juge de la Cour Suprême.
Cour de District de St-Martinville,
Affaire Barra.—15 nov. 1859.

Saint-Jean-Baptiste
(Louisiane)
Imprimerie du Meschacébé et de l'Avant-Coureur.
1861

VIGILANCE COMMITTEES. Shortly before the Civil War, lawlessness in the Attakapas region had gotten so out of hand that leading citizens formed vigilance committees to deal with the problem. The Lafayette Committee for Mutual Protection gained legitimacy from the participation of former governor Alexandre Mouton, who was chosen president, and effectiveness from his son, Alfred, a graduate of West Point, who served as military commander. After a series of individuals were punished for their crimes, the vigilantes confronted the remaining outlaws at their stronghold at Queue Tortue. Possessing superior numbers and a small cannon, they quickly overwhelmed the outlaws in a bloodless confrontation. Some were whipped and many were exiled, ending the threat of the outlaws. But the vigilantes were widely criticized by government officials and in the press for taking the law into their own hands. To explain their actions, Alexandre Barde, a journalist and vigilance committee member from St. Martinville, wrote and published this book, *Histoire des Cimités de Vigilance aux Attakapas* (History of the Vigilante Committees of the Attakapas.)

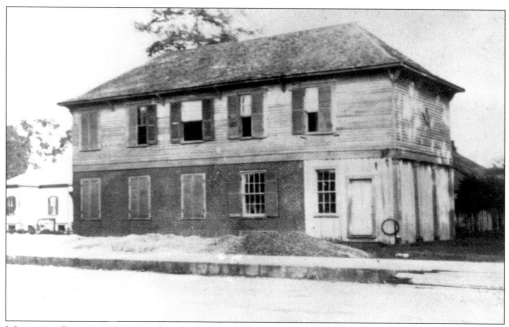

MASONIC LODGE. Hope Lodge No. 145 was chartered in 1857, and in 1861, former governor Alexandre Mouton, who was a member, donated this lot for the site of its lodge. Originally it was a one-story building, which was also used as a school; the second floor was added after the Civil War. The building was demolished in 1916 and a new structure built on the site.

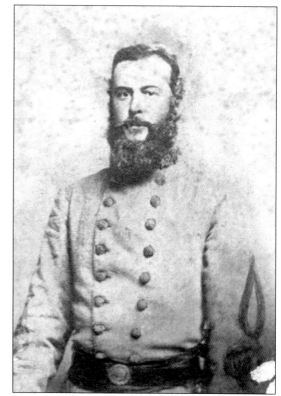

BRIG. GEN. ALFRED MOUTON. Eldest son of Gov. Alexandre Mouton and a graduate of the U.S. Military Academy, Jean-Jacques Alexandre Alfred Mouton joined the Confederate army at the start of the Civil War and rose to commander of the 2nd Division, Trans-Mississippi Department. He was highly esteemed by the largely Cajun forces he led. General Mouton was killed leading a Confederate charge at the Battle of Mansfield on April 8, 1864.

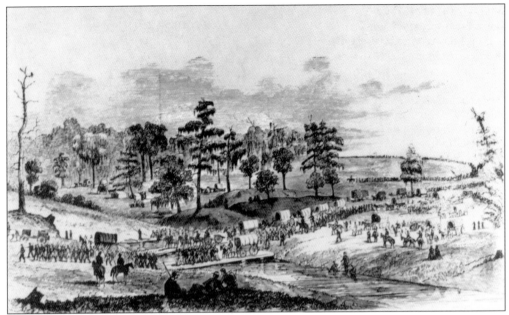

BANKS'S ARMY CROSSING VERMILION BAYOU, OCTOBER 10, 1863. During the Civil War, Gen. Nathaniel P. Banks led the Texas Overland Expedition through Louisiana, passing through Vermilionville. Although Confederates had burned the bridge at Pin Hook, Union engineers quickly replaced it with a pontoon bridge. The Federal troops foraged widely in the area, and what they could not take, they often destroyed to prevent it from being used by the rebels.

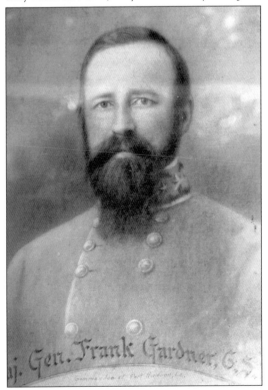

GEN. FRANKLIN K. GARDNER. A native of New York and a graduate of West Point, Gardner was married to the daughter of Gov. Alexandre Mouton, and he cast his lot with the Confederacy when the Civil War broke out. As commander of the Confederate garrison at Port Hudson, he held out against a much larger Federal force until starvation forced him to surrender. After the war, he became a planter at Lafayette.

William Britton Bailey. A journalist before the Civil War, W. B. Bailey returned to Vermilionville after serving in the Confederate army and founded the *Advertiser*. Although not the town's first newspaper, the *Advertiser* is the oldest one still in existence. The paper began as a four-page weekly, two pages in English and two in French. Bailey later served as mayor of Vermilionville, then as clerk of court for Lafayette Parish.

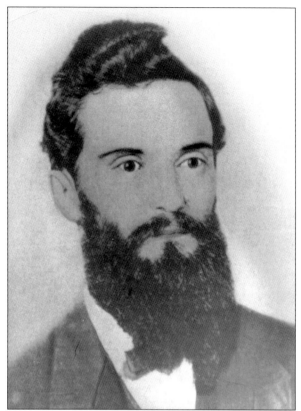

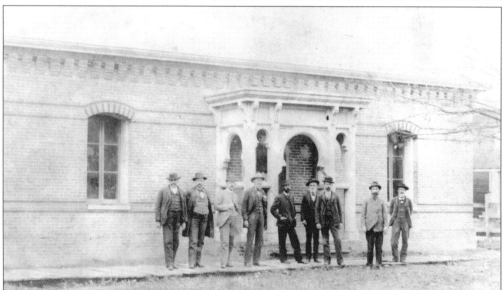

Recorder's Office. The wood-framed courthouse was not a safe place to store paper records, so in 1869, Lafayette Parish constructed this building next to the courthouse to house the recorder's office. It was built of brick and contained fireproof storage vaults to protect the parish's records. Lafayette Parish is fortunate in that it has never had a courthouse fire destroy its historical records as so many other parishes have.

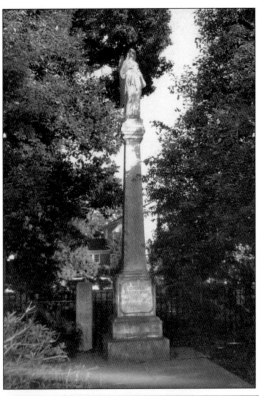

HEBREW REST CEMETERY. In 1869, former governor Alexandre Mouton donated a plot of land to the Jewish people of southwest Louisiana to be used for a cemetery. In gratitude for this gift, the Jewish community erected this monument in his honor in the cemetery. The cemetery is still used by Jews from throughout the Acadiana region.

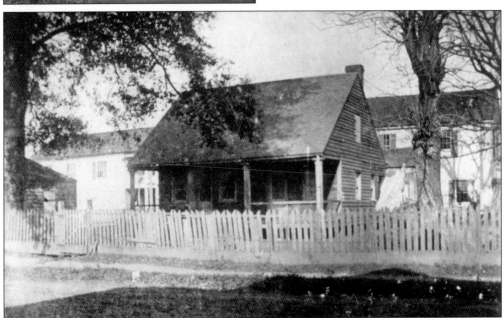

MRS. HOMER BAILEY'S SCHOOL. Around 1870, Emily Bailey and her mother, Palmyre Fleming, kept school in their house on the corner of South Washington and West Main Streets. Boys and girls were given a basic education, including penmanship and catechism, from first to sixth grade. At the time, public schools were inadequate, and prominent parents preferred to send their children to parochial schools or private schools such as this one.

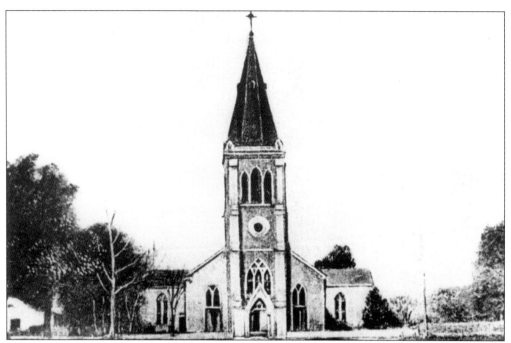

ST. JOHN'S CHURCH. After a storm demolished the steeple in 1871, the church was repaired, remodeled, and enlarged by Fr. John Ernest Forge. His renovations included the massive Flemish tower, a galvanized iron roof, electric lights, two stained-glass windows, and a hand-carved altar from Turin, Italy. The final touch was the installation of a 3,300-pound bell donated by the black members of the congregation in 1888.

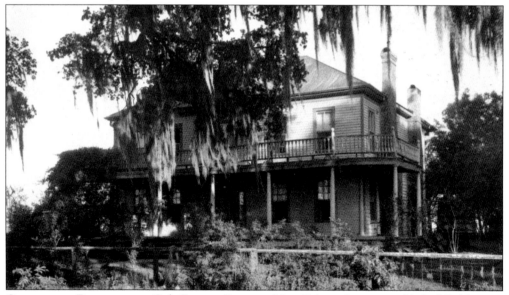

OAKBOURNE PLANTATION. Col. Gustave Breaux, a New Orleans lawyer, established Oakbourne Plantation east of Vermilionville in the 1870s. The land later belonged to Jack Nickerson, who in 1956 sold 150 acres to a group of investors to form Oakbourne Country Club, Lafayette's first country club. Coteau Ridge, the west bank of an old bed of the Mississippi River, runs through the property, providing an ideal setting for the golf course.

PRESBYTERIAN CHURCH. The second Protestant congregation organized in Vermilionville was the First Presbyterian Church in 1875. Among the earliest members were the Hayes, Torrance, Greig, McFaddin, Adams, and Mudd families. This church built on Buchanan Street in 1878 and the Sunday school added in 1927–1929. These facilities served the congregation until the current church was built on Johnston Street and University Avenue in 1946.

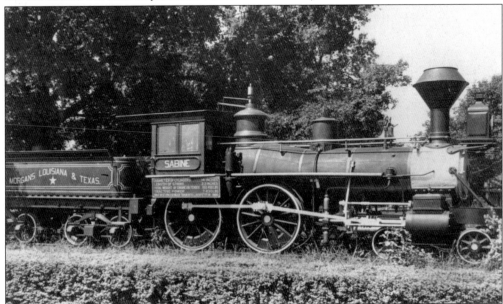

THE ENGINE SABINE. The first locomotive to arrive at Vermilionville was the *Sabine*, a work engine of the Louisiana and Texas Railroad. The Southern Pacific donated the engine to the City of Lafayette in 1923 as a monument to the achievements of early railroad builders. It stood in a park next to the railroad station until the city donated it for scrap metal during World War II.

Two

THE PROGRESSIVE YEARS

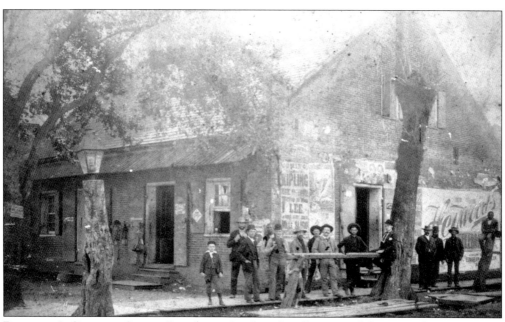

REVILLON'S GENERAL STORE. Frenchman Joachem Revillon owned this general store on Main and Washington Streets between the courthouse and the church. The building was constructed about 1850 and demolished in 1900. In this picture taken about 1890, traces of the frontier remain in the crudely lopped-off tree stumps and the hitching post built onto the tree trunk, but refinements are also apparent in the plank sidewalk and the gaslight.

JEWISH TEMPLE. The Hebrew Association of Rodeph Sholom was organized in 1880 as an Orthodox congregation. The following year, Alexandre Mouton donated two lots on Lee Avenue for the purpose of building a temple, and this building was constructed in 1882. The congregation joined the Reform movement in 1898. The temple has been extensively remodeled since then, and a social hall, kitchen, classrooms, rabbi's study, library, and new entrance were added.

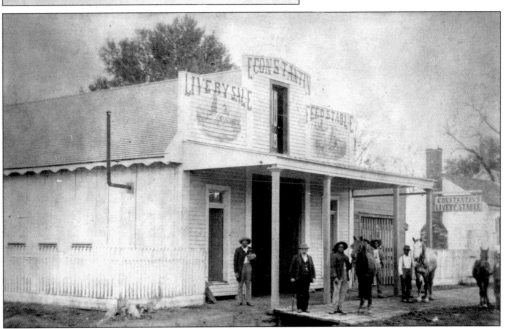

CONSTANTIN'S LIVERY STABLE. During the late 1800s, Ernest Constantin's livery stable stood on Madison Street near the courthouse. The livery stable was his principal business, but Constantin was also involved in farming and stock raising outside of Lafayette and owned several buildings and undeveloped lots within the city. As times changed, the stable became a hardware and agricultural implements store, then sold buggies, automobiles, and implements.

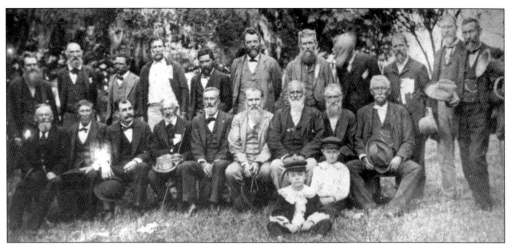

CONFEDERATE VETERANS, 1888. Confederate veterans gathered at Beau Sejour, the plantation home of Maj. Jean Sosthene Mouton. Shown from left to right are (seated on the ground) Frank Meyers and Dave Church; (seated) A. C. Allen, Christian Steiner, William Clegg, ? Ware, Pierre Bernard, Martial Martin, Jean Sosthene Mouton, Sidney Greig, and William B. Torian; (standing) Samuel Montgomery, Arthur Greig, Alexander Comeaux, Tibus Dugas, Lucien St. Julien, Louis Breaux, Leonidas Creighton, Joseph A. Chargois, Auguste Lisbony, J. C. Buchanan, and Douglas Cochrane.

LAFAYETTE HARDWARE STORE. This building on the corner of Vermilion and Buchanan Streets was probably built around 1890 by the Hopkins family. It was originally divided to house two businesses, hence the two doorways. The Lafayette Hardware Store occupied the building during most of the 20th century. After it closed, the building was leased to the Lafayette Artists' Alliance for several years, and it now houses an architectural firm. (Lucien Martin.)

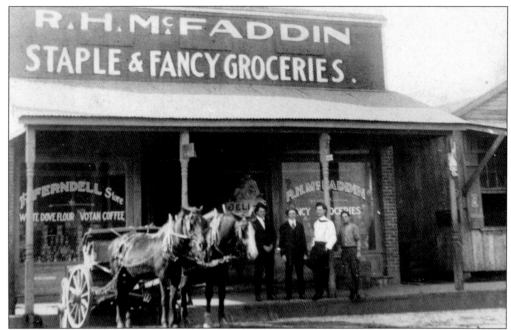

McFaddin's Grocery Store. Theodore McFaddin opened this store about 1890, on Jefferson Street near Garfield opposite where the Episcopal Church of the Ascension was later built. A typical grocery store of its day, it stocked a variety of dried foodstuffs in bins, with canned goods and jars of candy on shelves behind the counter. Under the ownership of Theodore's son Robert, the store remained at this location until 1944.

Falk's General Store and Opera House. Mary Plonsky Bendel and her second husband, Benjamin Falk, operated a general store, Falk's Mercantile, on the lower floor of this building, located on South Washington Street between Vermilion Street and Convent. The upper floor, grandly known as Falk's Opera House, was the entertainment center of town. Traveling vaudeville artists and opera troupes performed there, and it was often the site of public dances as well.

OLD CITY HALL. The first bank in Lafayette was chartered as the People's State Bank of Lafayette in 1891 and four years later rechartered as the First National Bank of Lafayette. Its original building, on West Main Street across from the courthouse, was designed and built by George Knapp in 1989. Knapp was a local architect who had taught himself his profession from correspondence school courses. He also designed the Gordon Hotel, the Masonic Temple, and numerous homes in Lafayette and New Iberia. The bricks for this building were made locally in Paxton's Brick Yard and laid by Richard Chargois. Lumber and hardware were purchased from the A. J. Moss and Emile Mouton Lumber Company. In 1906, after the bank moved to its new location on Jefferson Street, the City of Lafayette purchased this building to serve as Lafayette's first city hall. After the second city hall was built in 1939, it housed the public library. Today the building has been beautifully restored and houses the offices of the Council for the Development of French in Louisiana.

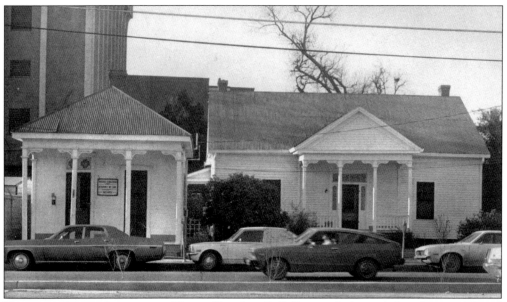

HYPOLITE SALLES OFFICE AND HOME. Hypolite C. Salles was Lafayette's first doctor of dental surgery, at a time when there were less than 400 degree-holding dentists in the United States. He began his practice in 1883 and built this office at 514 Buchanan Street in 1890 and the house next door in 1891. The house remained occupied by family members until 1984, when both buildings were moved to Acadian Village.

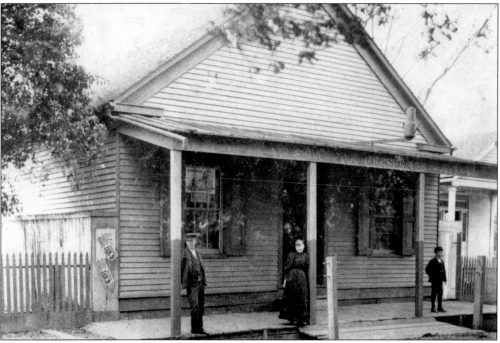

JOHN GRASER AND SONS TINSMITHS. The first tinsmiths in Lafayette were John Graser and Sons, who founded their business in 1892. Note the coffee pot mounted above the porch roof. The building stood at 107 West Vermilion Street, later the site of the Lafayette Building Association. Pictured here are John Graser Jr. and Carrie Graser. The boy is unidentified.

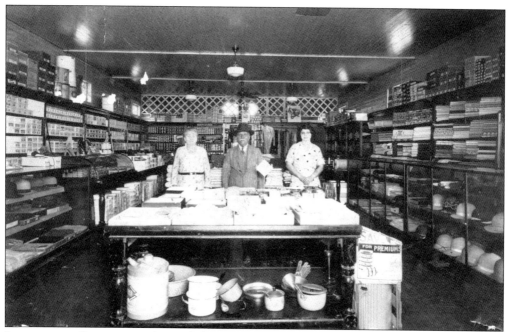

LEBANESE IN LAFAYETTE. Around the end of the 19th century, a large number of Lebanese immigrants came to southwest Louisiana, drawn in part by the prevalence of the Catholic religion and the French language. Approximately 80 Lebanese families settled in Lafayette. Among the earliest to come was Racheed Saloom, who arrived in 1893. His general store stood on the corner of St. John and Voorhies Streets.

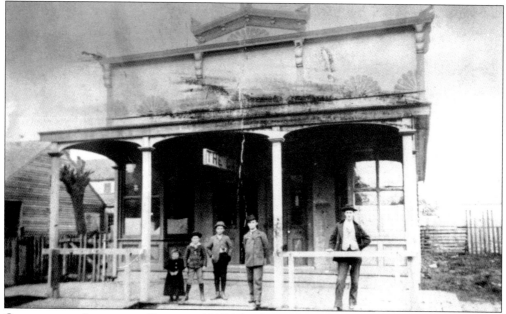

OFFICE OF THE *LAFAYETTE GAZETTE*, 1895. The *Gazette* was a four-page, weekly English-language newspaper founded by Homer Mouton in 1893. The press was first located in the hall of Mrs. Bailey's school. The *Gazette* became a daily in 1920 and was absorbed by the *Daily Advertiser* the following year. (Lucien Martin.)

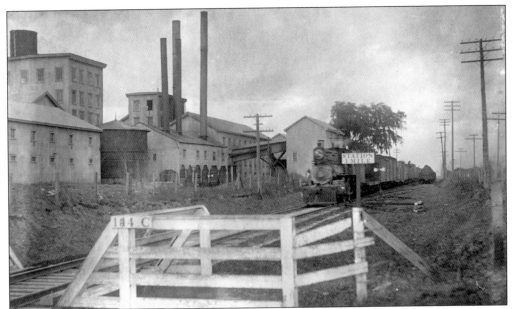

LAFAYETTE SUGAR FACTORY. Incorporated in 1895, the Lafayette Sugar Factory was located on Oak Street near the railroad tracks on the south side of town. During the grinding season, A. B. Denbo, the manager, lived at a boardinghouse near the factory along with other workers, as the roads were too rough for him to commute from his home a mile away. The factory was destroyed by fire in 1922.

LAFAYETTE STREET. The streets of Lafayette were originally lined by rows of oak trees, which provided welcome shade from the summer's heat. However, the shade prevented the streets from drying out after one of Lafayette's frequent rains, making the roadway rutted and difficult to travel on. The city fathers had the trees cut down to aid traffic, but housewives were not pleased by the resulting dust that invaded their homes.

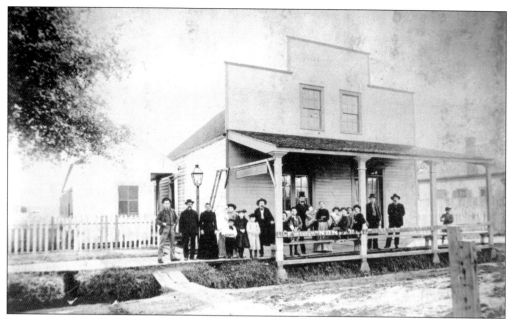

DOMENGEAUX'S GENERAL STORE. Proud of their recent civic improvements, a group of citizens poses for a photograph in front of Domengeaux's General Store. A neat plank sidewalk stretches along the ditch, which is crossed by more planks, and a gaslight provides illumination at night, even if the road is unpaved. The rail in front of the store bears the inscription "Use Dr. Smith's Nonpareil for Nausea."

BEGNAUD'S SALOON. Simeon Begnaud moved his saloon from Carencro to Lafayette after his brother Martin's brutal murder in 1890. The new location was most advantageous: the corner of West Main and Lafayette Streets, opposite the courthouse. Needless to say, it was a popular gathering place for the courthouse crowd for many years. According to one source, "Many social and political plots found their birth, and sometimes their death, there."

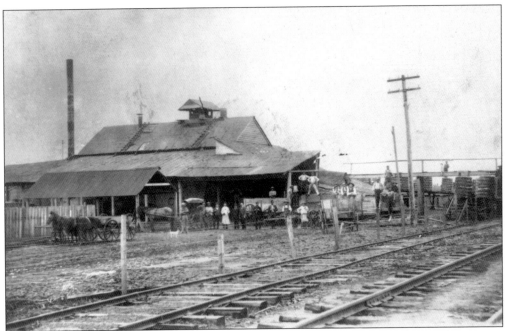

NEW INDUSTRY. The arrival of the railroad stimulated new economic growth as Lafayette now had a way to gather agricultural produce from the surrounding countryside and ship it to markets in New Orleans or as far away as San Francisco. New industries, most processing agricultural products, sprouted up along the tracks on the edges of town. These included a gristmill and an ice factory across the tracks from downtown and a cotton gin, a compress, a cottonseed oil mill, and a brick manufacturer north of town where the tracks north and west split. Pictured above is the Gerac Cotton Gin; below is the People's Cotton Oil Company.

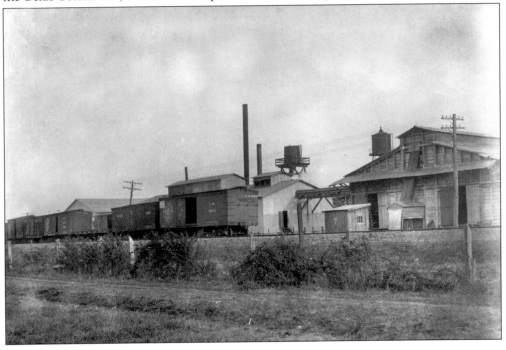

COTTAGE HOTEL. Located on the northwest corner of West Vermilion and Jefferson Streets, the Cottage Hotel was originally a private residence. As Jefferson Street developed into the commercial center of town, the sprawling, tree-shaded house was converted into a hotel for drummers, or traveling salesmen. Ada Young, the proprietress, stands on the steps fifth from the left, with her two daughters and some friends from town.

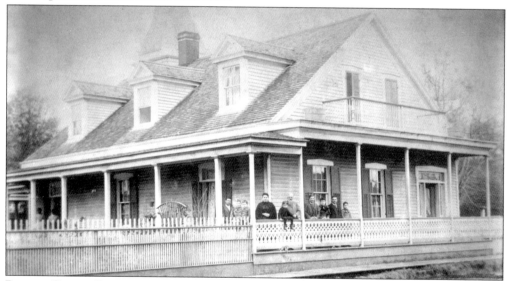

PIERRE GERAC RESIDENCE. Jean and Pierre Gerac were young Frenchmen who came to Vermilionville in 1855. They became large landowners and operated many businesses, including a cotton gin and a general store. Pierre Gerac's home stood on St. John Street south of the church and served as the first home of Cathedral School. It was moved across the street when the bishop's residence was built and today houses law offices.

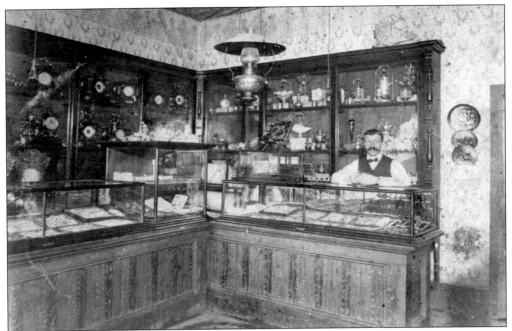

KRAUSS JEWELRY STORE. Paul Krauss opened his jewelry store on Jefferson Street in 1898. The display cases held a variety of jewelry, and the shelves behind the counter displayed clocks and silverware. The original store stood next to Maurice Heymann's department store but later moved across Jefferson as Heymann's expanded. Krauss, succeeded by his sons Jules, Louis, and Paul Jr., continued to operate the store for 60 years.

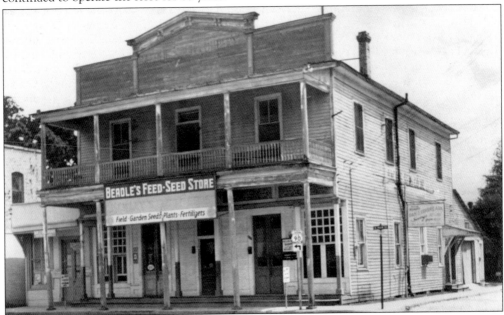

CLEGG'S DRUG STORE. This building on the corner of West Main and Lafayette facing the courthouse was originally a drugstore owned by William Clegg, who also had operated a private bank in Lafayette before the Civil War. Beadle's Feed and Seed Store occupied the building for many years, continuing in operation through the 1960s. The upstairs housed attorneys' offices.

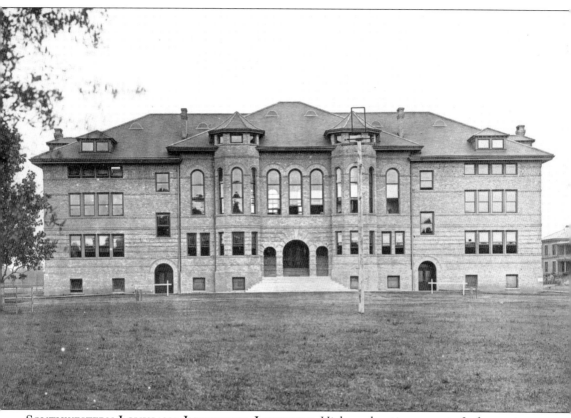

SOUTHWESTERN LOUISIANA INDUSTRIAL INSTITUTE. Higher education came to Lafayette in 1900 when the board of trustees decided to locate Southwestern Louisiana Industrial Institute there. The Girard family gave 25 acres of land, local citizens pledged $8,000 in cash, and the parish passed a two-mill property tax to support the school. Local banks offered loans totaling $10,000 against the proceeds of the tax, so the school could begin work immediately. Classes began in 1901, with 100 students and 8 teachers. Tuition was free, and students were expected to have completed the sixth grade. The first president was Edwin Lewis Stephens, who served for 38 years. The Main Building, shown here, was later named Martin Hall in honor of Robert Martin, state senator from St. Martinville, who first proposed establishing a college in southwestern Louisiana and who chaired the original board of trustees.

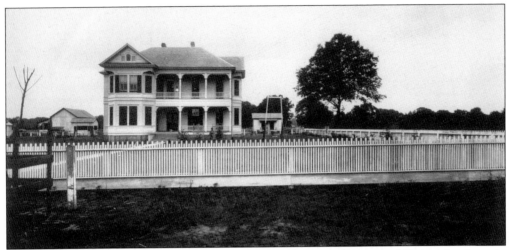

ROY HOUSE. In 1900, J. Arthur Roy built this house at Johnston Street and University Avenue, across from Southwestern Louisiana Industrial Institute (now University of Louisiana at Lafayette). Roy served on the board of trustees for SLII. Originally there were stables, servants' quarters, and a washhouse behind the house. It was occupied by members of the Roy family for nearly 80 years and is now owned by UL Lafayette.

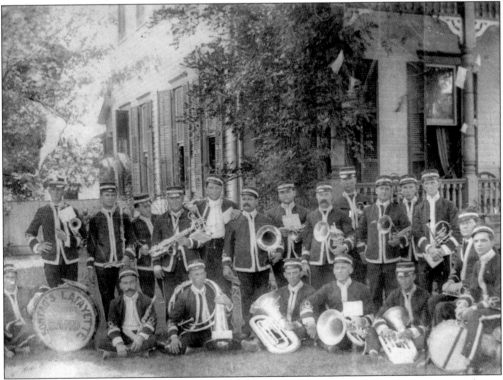

SONTAG'S CONCERT BAND. During the Progressive Era, brass bands were often a source of civic pride in small towns across America. Florent Sontag, a native of Breaux Bridge and member of an illustrious musical family, headed the music department at Southwestern Louisiana Industrial Institute from 1901 to 1918. In addition to his teaching duties, he organized and directed the Lafayette Brass Band in the early years of the 20th century.

EPISCOPAL CHURCH. Episcopalians held services in the Presbyterian church for some years before 1901, when the Episcopal Church of the Ascension was built at the corner of Jefferson and Garfield Streets, where Dwyer's Cafeteria stands today. The lot was donated by Judge J. G. Parkerson. This building continued in use for half a century before the congregation moved to their current location on Johnston Street.

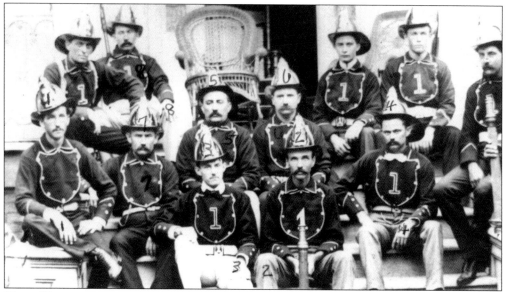

HOBO VOLUNTEER FIRE COMPANY. In 1898, the men of Lafayette organized a volunteer fire department with 25 members, named the "Hoboes" because of the rough clothes they wore in their work. Their equipment consisted of a two-wheeled hose truck pulled by hand and 200 feet of hose, which produced enough pressure to throw water on any building in town. The company became the core of today's Lafayette Fire Department.

41

LAFAYETTE PARISH AGRICULTURAL FAIR. In 1901, a group of businessmen organized the Lafayette Parish Fair Association, which sponsored an annual fair to highlight the parish's agricultural production and to bring the latest innovations to area farmers. The association developed the fairgrounds northeast of Lafayette on Mudd Avenue, where City Park is today. This picture was taken around 1912. (Lucien Martin.)

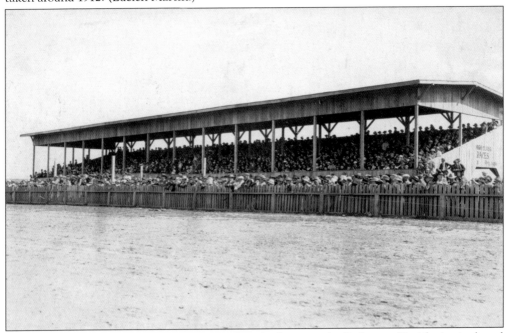

LAFAYETTE FAIRGROUNDS RACE TRACK. Besides hosting the Lafayette Parish Agricultural Fair, the fairgrounds included baseball fields as well as the racetrack, grandstand, and stables. In 1920, the city purchased the fairgrounds for a public park, which was developed to include the Municipal Golf Course and a baseball field named for Dr. L. O. Clark, an early advocate of public recreation areas.

PIN HOOK BRIDGE. The bridge over the Vermilion River at Pin Hook has undergone many transformations in its time. In the days when automobiles were a novelty, it was a simple wooden structure wide enough for a farm wagon, on a dirt road leading through sugarcane fields to New Iberia. Only a handful of houses and businesses lined the road between the bridge and Lafayette.

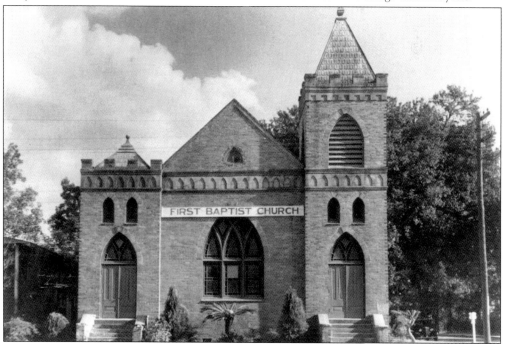

FIRST BAPTIST CHURCH. First Baptist Church of Lafayette was founded in 1902 with five charter members. It met in various borrowed locations until 1909, when this modest little brick building was built. Standing at Lee Avenue and Oak (now Jefferson) Street, the church could seat 300 and had electric lights. It continued to serve the congregation for nearly 40 years.

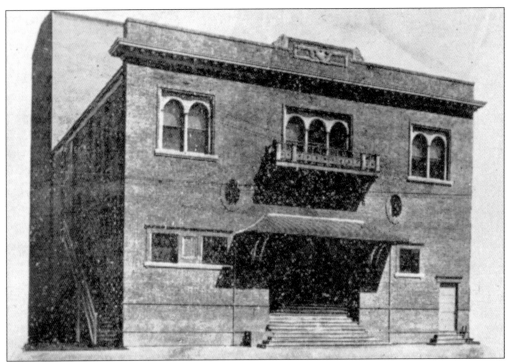

JEFFERSON THEATRE. In 1899, a group of progressive-minded businessmen organized the Lafayette Improvement Association, a precursor to the chamber of commerce. Besides supporting civic betterment projects such as public schools, the electric light and water systems, and Southwestern Louisiana Industrial Institute, the association organized a stock company to build the Gordon Hotel and the Jefferson Theatre, which stood on Jefferson Street next to the Gordon.

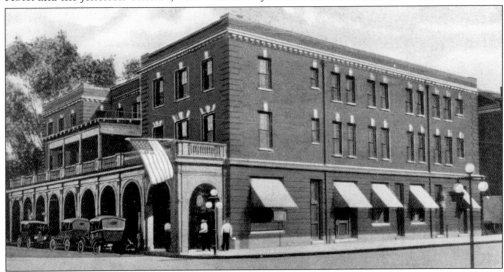

GORDON HOTEL. The first modern hotel in Lafayette was the Gordon, constructed in 1904 by the Lafayette Improvement Company, which also built and operated the adjacent Jefferson Theatre. The hotel boasted steam heat and hot and cold baths. It was a hub of commercial, civic, and social activities for decades. As its popularity declined, it was converted to apartments in the 1960s and now houses offices and retail space.

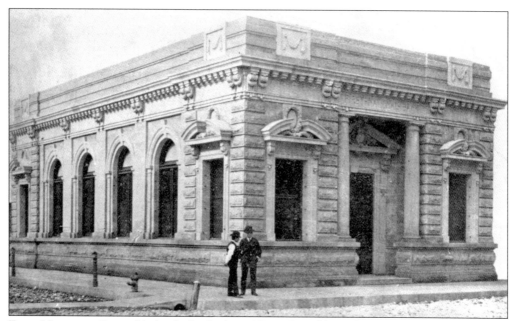

FIRST NATIONAL BANK. Under the leadership of Crow Girard (president), S. R. Parkerson (cashier), and Pierre R. Roy (auditor), First National Bank rapidly outgrew its original building on West Main Street. In 1905, the bank moved to this building on Jefferson and Vermilion Streets, reflecting the shift of the center of the business district from the courthouse area to Jefferson Street.

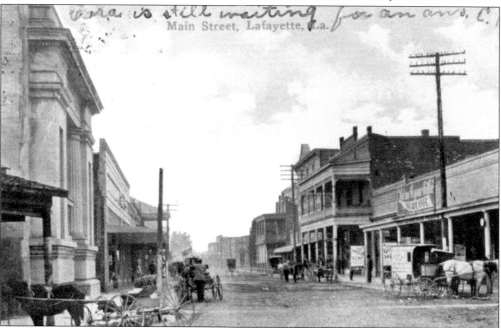

JEFFERSON STREET. The railroad tracks were built east and north of Vermilionville, not through town. Jefferson Street and its extension, Lincoln Avenue, which crossed the tracks, became the preferred business location. But the street was too narrow to support major commercial activities, so the merchants on the east side moved their buildings back 15 feet and donated the land, while the merchants on the west paid for the move.

PAUL BREAUX. The son of former slaves and a graduate of Tuskegee Institute, Paul Breaux opened a primer school for black children at Good Hope Baptist Church in 1900. The Lafayette Parish School Board provided a building for his school beginning in 1906 and in 1926 purchased Ile Copal to house his school, which by then comprised eight grades. Breaux also headed relief efforts for blacks during the 1927 flood.

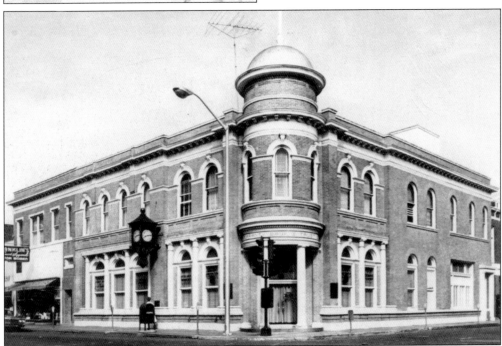

GUARANTY BANK BUILDING. This building on the corner of Congress and Jefferson Streets was built for the Bank of Lafayette in 1905. The bank struggled during the Depression and in 1931 was bought by the Commercial Bank of Lafayette, which in turn closed in 1936. The Guaranty Bank and Trust Company, formed in 1937, first leased the building then purchased it four years later. Today it houses a restaurant and apartments.

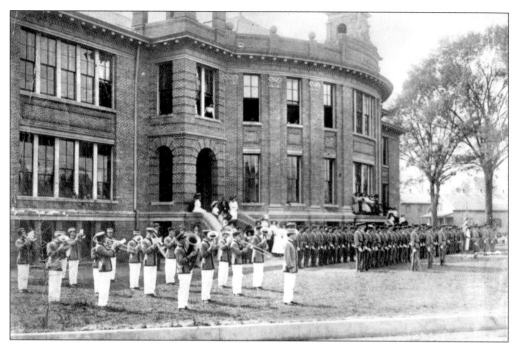

SOUTHSIDE HIGH SCHOOL. Lafayette's first graded public high school was built in 1906 with the proceeds of the parish's first tax for school buildings. It stood on the triangular block bounded by Main Street, Jefferson Street, and Lee Avenue. After Lafayette High School was built in 1926, this building served as an elementary school and then housed the public library. In this picture, the SLII band and cadets perform on the school grounds.

DR. G. A. "BEDON" MARTIN. One of the most colorful characters in Lafayette history was Dr. George Armand Martin, nicknamed "Bedon" for the high silk hat he always wore along with a Prince Albert coat. Physician, planter, politician, city judge, scholar, and raconteur, he also served as the first King Attakapas, presiding over Lafayette's Mardi Gras celebration in 1897. The stories he told and that were told about him are legendary.

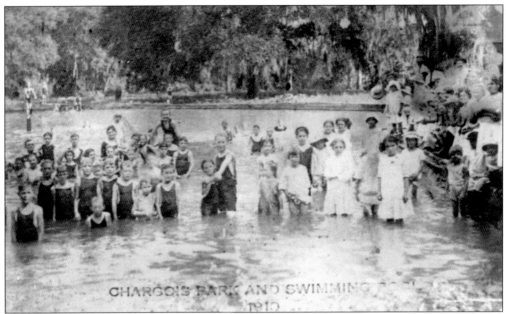

CHARGOIS SPRINGS. These natural springs near the Vermilion River east of Lafayette became a popular recreation spot early in the 20th century. Cas Chargois enclosed the springs with a low brick wall to make a wonderful swimming hole, cool and clear, while a shady grove nearby was a perfect place for picnics. Flood control measures on the river after the 1927 flood caused the springs to dry up.

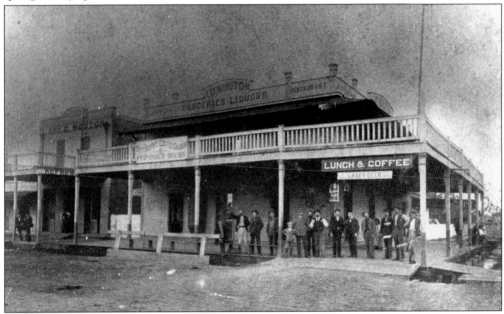

JOHN O. MOUTON'S STORE. This store stood on Lincoln Street near the railroad tracks and offered a wide array of merchandise and services. More than a grocery store, Mouton's also included a restaurant, coffee shop, and saloon and furnished rooms to rent. John O. Mouton, a grandson of Jean Mouton, was a major in the Confederate army and served as mayor of Vermilionville during the 1870s. (Lucien Martin.)

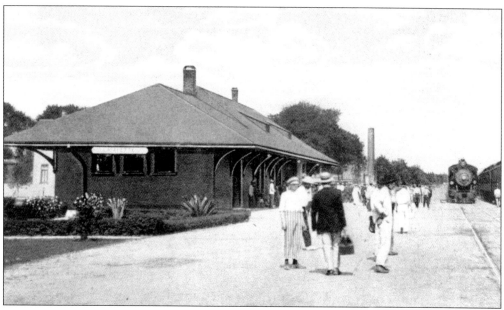

RAILROAD DEPOT. The passenger depot was constructed in 1911, when the line from Baton Rouge to Lafayette was opened. The depot sheltered separate waiting rooms for whites and blacks and a baggage room. Because Lafayette was a division headquarters and midway between New Orleans and Houston, all passenger trains stopped here for meals and to change crews. The depot was damaged in a fire in 1990 but has been restored.

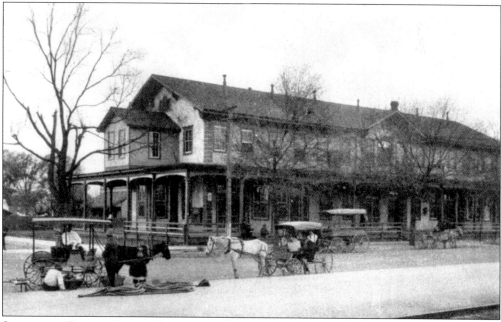

SOUTHERN PACIFIC OFFICE BUILDING. This structure, which stood on Grant Street near the passenger depot, was sometimes called the Lafayette Hotel and was a hotel or boardinghouse for railroad employees in addition to housing the Southern Pacific Railroad's division offices. The lunch room, the Brown News, was a popular place for the young people of Lafayette to socialize. The building was destroyed by fire in the early 1970s.

DR. L. O. CLARK. A native of Ridge, Louisiana, Lambert Oran Clark graduated from Tulane University with a degree in medicine in 1905 and arrived in Lafayette just in time to help with its last serious yellow fever epidemic. He helped found the Lafayette Sanitarium in 1911, working to overcome people's fear of hospitals and encouraging sound health practices. He was also a strong advocate for Lafayette developing public recreational facilities.

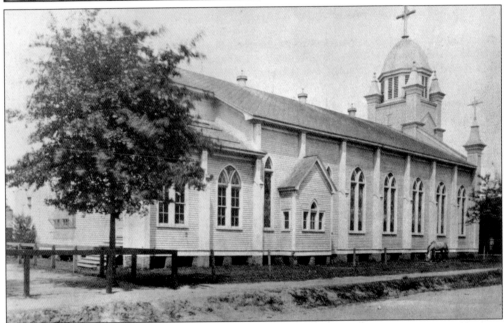

ST. PAUL'S CHURCH. As plans were being made to rebuild St. John's Church, black parishioners, who were dissatisfied with segregated seating, requested a church of their own. St. Paul's Church was built in 1912, and the old bell from St. John's hung in its steeple. The parish school, which was expanded to include a high school in 1921, continued to operate until the 1970s.

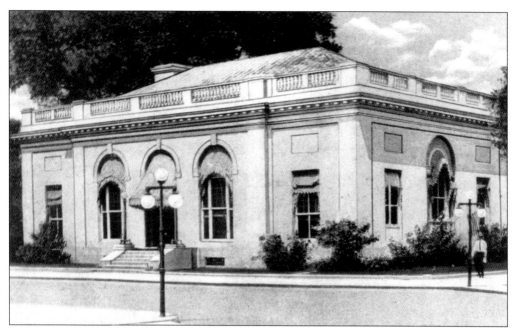

POST OFFICE. Free home mail delivery began in the early 20th century when the town erected street signs and numbered houses within the city limits, but the post office remained a popular place to meet people and catch up on news. Centrally located on Vermilion and Jefferson Streets, this building served from 1915 until the late 1950s, when the Federal Building was constructed on Jefferson and Main Streets.

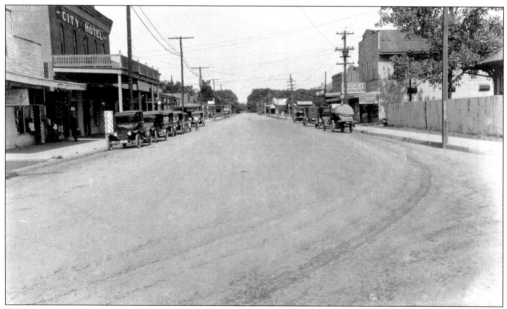

LINCOLN AVENUE. Jefferson Street took a turn to the northeast and became Lincoln Avenue as it approached the Southern Pacific railroad tracks and crossed the tracks at a right angle. Beyond the tracks stood the City Hotel and a short continuation of the business district, including a gasoline station, a bakery, and the People's Pharmacy. Beyond was a residential area. Lincoln Avenue was renamed Jefferson Street in the 1930s.

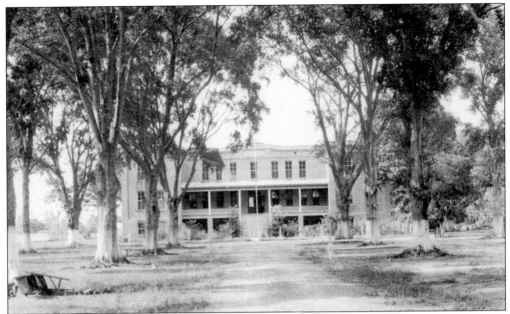

HOLY ROSARY INSTITUTE. This Catholic school for blacks was founded in 1913 by Fr. Phillip Keller and staffed by the Sisters of the Holy Family and priests and brothers of the Society of the Divine Word. Over time, the campus added more buildings—chapel, dormitory, dining hall, auditorium, gymnasium, and industrial arts shop—to serve as many as 500 students. The school closed in 1993. (Diocese of Lafayette Archives.)

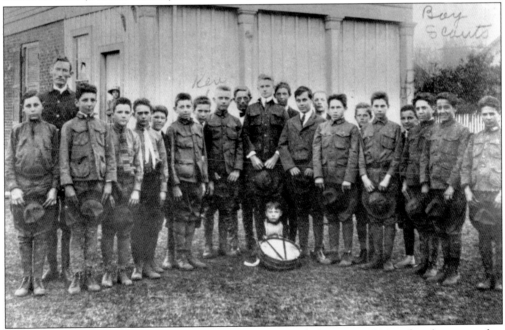

BOY SCOUTS. The first Boy Scout troop was organized in Lafayette in 1916, only a few years after the Boy Scouts of America was organized. There were 34 members in the first troop, many of whom gathered for this picture in front of the old Masonic Lodge. The Evangeline Area Council was organized eight years later. (Lucien Martin.)

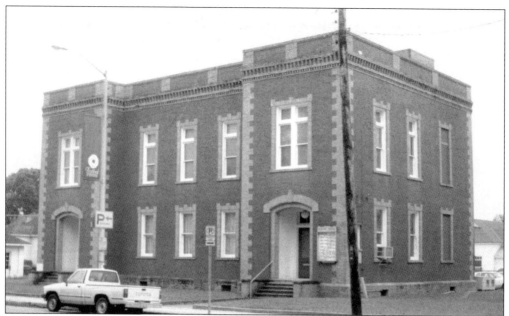

HOPE LODGE NO. 145. This unusual building was constructed in 1916 on the site of the Masons' antebellum lodge. The architect was George Knapp, and the contractor was A. Van Dyke, both members of the lodge. The Temple renovated in 1956, adding the kitchen, elevator, and air-conditioning, but the exterior remains much the same as when it was built. (John Stephan.)

GOOD HOPE HALL. During the early part of the 20th century, the social center of the black community was Good Hope Hall, on the corner of Stewart and Jackson Streets in the Freetown neighborhood. Built of cypress with pine floors, Good Hope Hall was a meeting place and dance hall where some of the best jazz bands in Louisiana played regularly. Today the building houses an attorney's office.

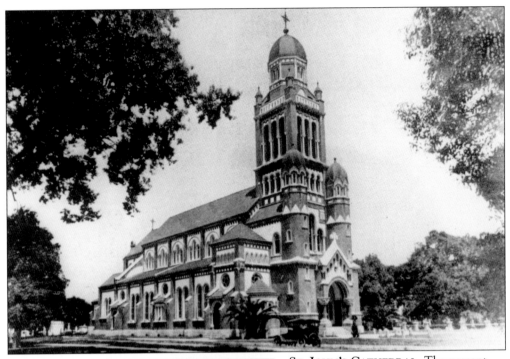

ST. JOHN'S CATHEDRAL. The present church was built on the site of the previous churches dedicated to St. John the Evangelist. The cornerstone was laid in November 1913 by Archbishop J. A. Blenk of New Orleans, and the church was consecrated three years later by the Most Reverend J. M. Laval. In December 1918, it became the cathedral when the Diocese of Lafayette was created.

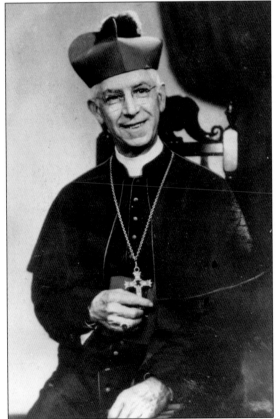

BISHOP JULES B. JEANMARD. A native of Breaux Bridge, Jules B. Jeanmard was appointed bishop of the Catholic Diocese of Lafayette when it was created in 1918. During his tenure, the Catholic population more than doubled and the number of priests quadrupled. He created 75 new parishes, 48 schools, an orphanage, a seminary, and a retreat house. Bishop Jeanmard retired in 1956 and died the following year.

Three

THE MIDDLE YEARS

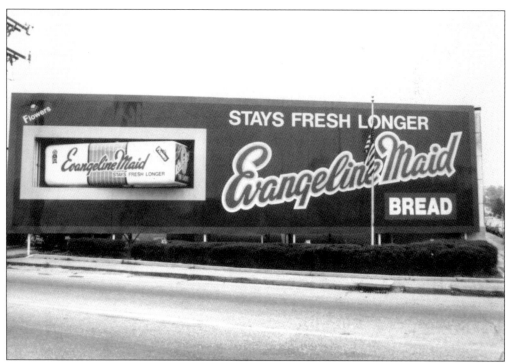

EVANGELINE MAID BAKERY. Joe Huval used his army bonus to open a bakery in Youngsville in 1919. A few years later, he moved the growing business to Lafayette. Eventually the company's market area extended across most of south Louisiana, from Lake Charles to Grand Isle. Huval's daughter Mary Helen was the model for the first Evangeline Maid, one of the earliest uses of Acadian cultural images in local advertising.

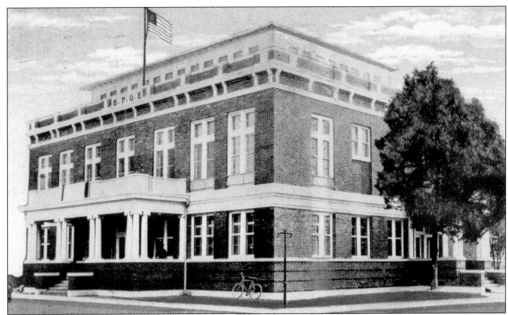

ELKS LODGE. Lodge No. 1095 of the Benevolent and Protective Order of the Elks was chartered on July 15, 1908. In 1920, the lodge built this structure on Congress and Buchanan Streets, containing a swimming pool, gymnasium, and card rooms as well as the lodge room and offices. Unfortunately, the lodge was not able to meet its mortgage payments during the Depression, lost its building, and dissolved in 1930.

BALDWIN LUMBER COMPANY. Built in 1920 on the bank of the Vermilion River, this sawmill produced 100,000 board feet daily and employed 600 men during the few years it was in operation. The abandoned mill site was used for a refugee camp during the 1927 flood and later housed B. F. Trappey's Sons canning factory. (Lucien Martin.)

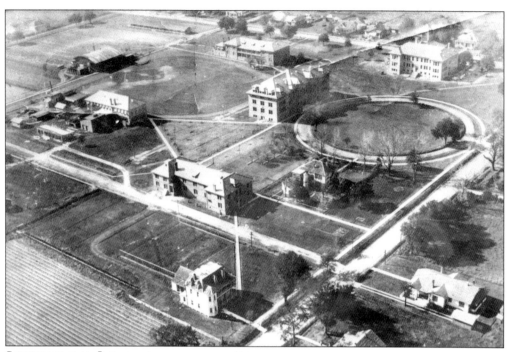

SOUTHWESTERN LOUISIANA INSTITUTE. In 1921, SLII became Southwestern Louisiana Institute (SLI), a four-year degree-granting college. The large building on the circular drive is Martin Hall (classrooms and offices). Clockwise around the quadrangle are the president's home, DeClouet Hall (women's dormitory), Brown Ayres Hall (classrooms), dining hall, Foster Hall (men's dormitory), and Girard Hall (classrooms and library). The white building in the foreground was another women's dormitory, called the St. Charles.

GENERAL MOUTON STATUE. The United Daughters of the Confederacy erected this statue of Gen. Alfred Mouton at the intersection of Jefferson Street and Lee Avenue. Gov. John M. Parker, Mayor R. L. Mouton, Judge W. F. Blackman, Bishop Jules B. Jeanmard, Mrs. Peter Youree of the United Daughters of the Confederacy, and Gen. A. B. Booth of the United Confederate Veterans were among the speakers at the dedication ceremony on April 8, 1922.

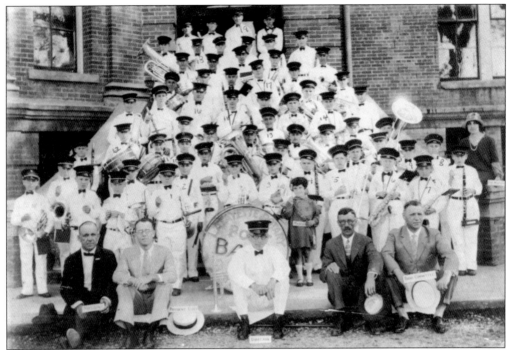

ROTARY BOYS' BAND. From 1922 to 1940, the Lafayette Rotary Club sponsored a boys' band for the dual purposes of providing musical training and promoting good citizenship. Frank Baranco served as musical director, and more than 200 boys participated in the band during its existence. The band performed at Rotary functions and gave concerts in town, traveled to Rotary conventions in other cities, and played at Gov. Huey Long's inauguration.

ABBEVILLE HIGHWAY. In 1912, the Parish of Lafayette passed a one-mill tax levy to build and maintain public roads and bridges within the parish. Dirt or gravel roads connected smaller towns with Lafayette, making the city a commercial center for the area. Shown here is the road to Abbeville in 1923 as it passed the SLI dairy farm, the area known today as the Horse Farm.

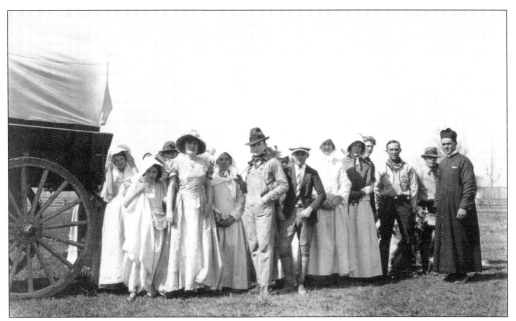

LAFAYETTE PARISH CENTENNIAL PAGEANT. In 1923, Lafayette Parish celebrated the centennial of its creation by staging an elaborate pageant at the fairgrounds. *The Attakapas Trail*, written by faculty members of Southwestern Louisiana Institute and starring local citizens, dramatized the history of the parish and the march of progress from the time of the Attakapas Indians and the earliest European settlement through the present and into the future.

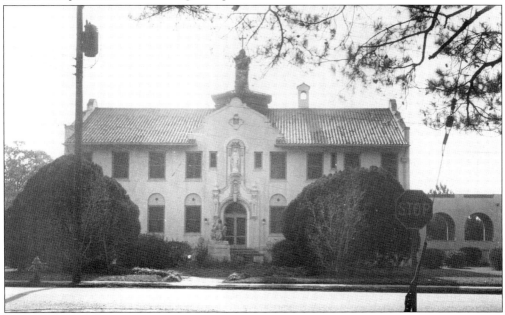

ST. MARY'S ORPHANAGE. A favorite project of Bishop Jeanmard was St. Mary's Home for Children, which opened in 1924. Staffed by the Sisters of Charity of the Incarnate Word from Houston, the home provided shelter and education to children from broken homes. Most children stayed only temporarily until their parents were able to care for them again or until other relatives could assume the responsibility.

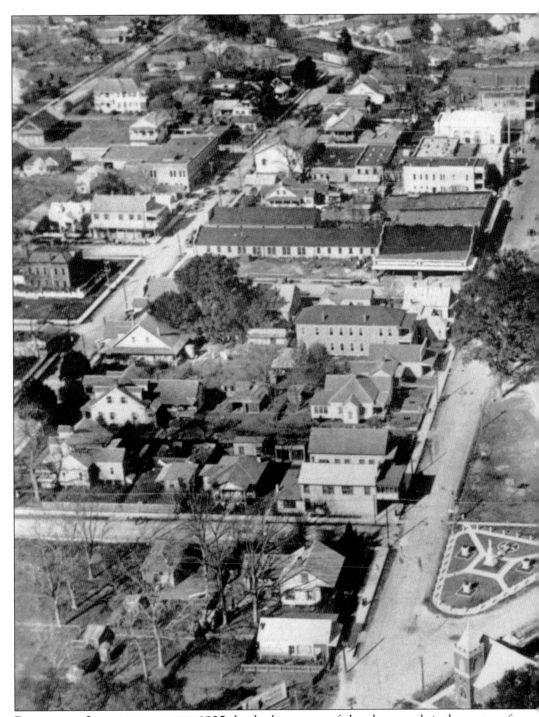

DOWNTOWN LAFAYETTE, ABOUT 1925. In the lower part of the photograph is the statue of General Mouton at the intersection of Jefferson Street and Lee Avenue. Behind it is Southside High School. Farther up Jefferson is the business district, including the Jefferson Theater and the Gordon Hotel, with the Masonic Temple to their east. At the upper edge of the photograph is the junior high school. The two-story building standing alone on the far left is the parish jail.

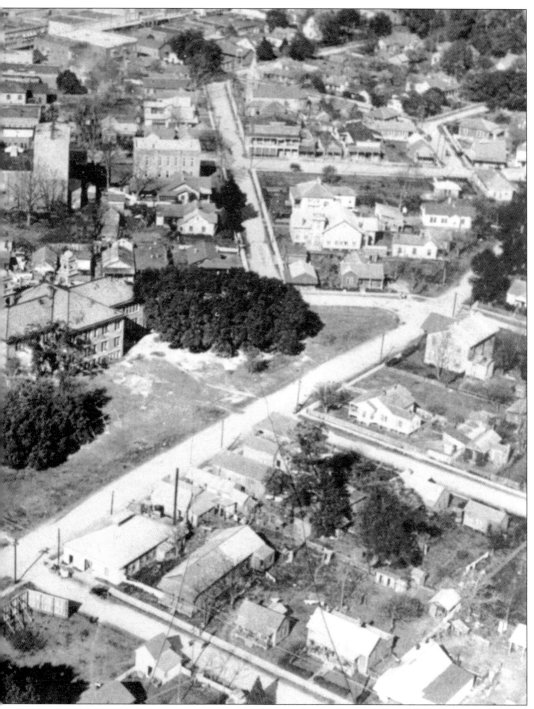

The long, one-story building between the jail and Southside High School is Lafayette Motors. First Baptist Church is across Lee Avenue from the statue. Streets in the center of the photograph run north-south and east-west, as laid out by Jean Mouton in the original town plat, while in the lower right they are oriented to the railroad tracks. Businesses are interspersed among the residences throughout the area.

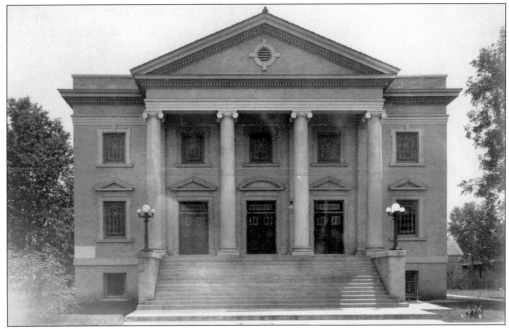

FIRST METHODIST CHURCH. First Methodist Church on the corner of Lee Avenue and Main Street was constructed in 1925 at a cost of $100,000. When it was dedicated on October 11, 1925, all of the Protestant churches in Lafayette suspended their services so that their members could attend. A choir of 50 voices sang, 25 Boy Scouts presented the colors, and 1,500 people were present.

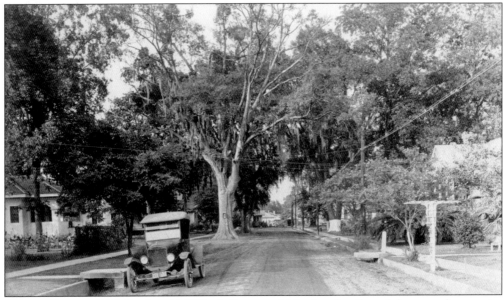

CHERRY STREET, 1925. By the mid-1920s, Lafayette neighborhoods reflected the general prosperity of the town. Automobiles allowed residents to move farther out from the original town site. Streets, while not paved, had curbs and gutters to control runoff, and power lines brought electricity and telephone service to homes. Urban residents had the leisure time to devote to lawns and gardens, and yards were planted with abundant trees, shrubs, and flowers.

DR. O. P. DALY. A graduate of Tulane Medical School, Oliver Perry Daly II came to Lafayette about 1915. At that time, he was the only surgeon in southwest Louisiana, traveling throughout the area to perform surgeries. He founded sanitariums in Abbeville and Opelousas and St. John Hospital in Lafayette. He later served as the first superintendent of the Lafayette Charity Hospital from 1937 to 1941 and again from 1952 to 1960.

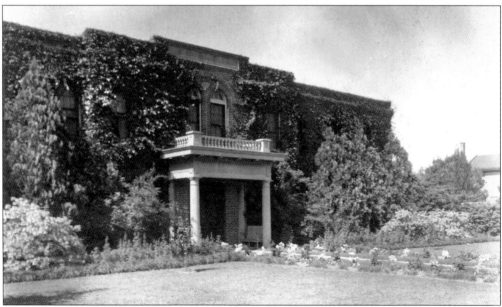

ST. JOHN HOSPITAL. In 1926, Dr. O. P. Daly built this two-story brick hospital on St. Mary Street in what previously was a cornfield. It was a modern facility for the time, with 25 beds and all the latest in operating, X-ray, and clinical facilities. Eleven years later, he sold the hospital to the State of Louisiana, which built the Lafayette Charity Hospital on the site.

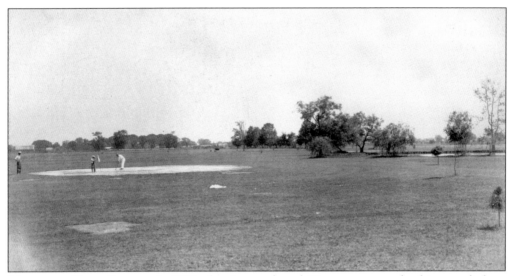

MUNICIPAL GOLF COURSE. In 1926, the city purchased 32 acres next to the fairgrounds from the Caffery family to build a municipal golf course. Originally there were nine holes, and the "greens" were made of sand. Golfers were required to smooth the greens with a wooden paddle after completing each hole. Shown here is the ninth green in 1927, when many of today's towering trees were newly planted saplings.

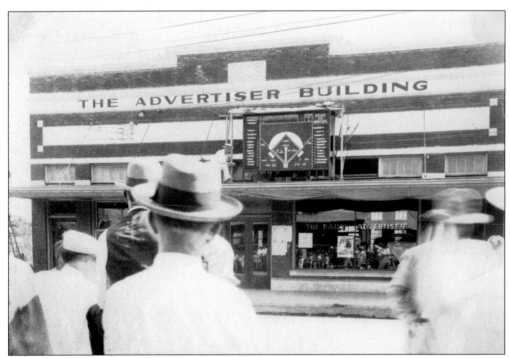

BASEBALL SCOREBOARD. The national pastime was also popular in Lafayette. During the 1926 World Series, the *Advertiser* mounted a large scoreboard on the marquee of its building. As the events of the game were reported on the national wire service, the man on the roof updated the scoreboard, while a crowd of eager fans waited in the shade across the street to "watch" the Cardinals battle the Yankees.

MAURICE HEYMANN AND HEYMANN'S DEPARTMENT STORE. Maurice Heymann opened his first store in 1917 and moved to this building on Jefferson Street in 1927. He pioneered the department store concept and introduced loss leaders to bring in customers. Aggressive pricing and advertising originally helped him compete with established stores, but his widespread philanthropy earned him unparalleled affection and lasting customer loyalty. He contributed generously to numerous schools, churches, hospitals, and other community projects. During the 1927 flood, he organized food supplies for the refugee camps in Lafayette; during the Great Depression, he held customers' checks until banks reopened and issued more than $100,000 worth of scrip; during World War II, Heymann's promoted bond drives and other activities to support the war. The store building now houses the Lafayette Natural History Museum, while the adjacent food center houses the Children's Museum.

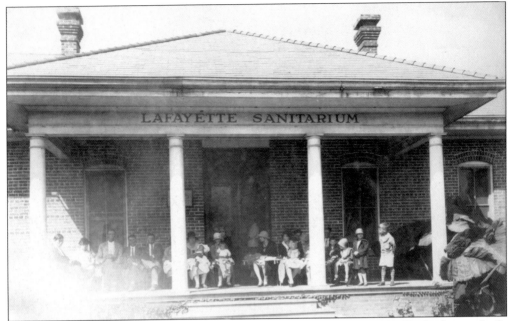

LAFAYETTE SANITARIUM. Lafayette's first hospital opened its doors in 1911. Under doctors L. O. Clark, J. Franklin Mouton, and L. A. Prejean, the facility treated any person in need of medical attention. Patients often paid with farm produce rather than cash. The sanitarium became Lafayette General Hospital in 1964. In this picture, crippled children line the porch on September 24, 1927, waiting for treatment at a monthly clinic conducted by Dr. W. S. Hatch.

PAUL BREAUX SCHOOL. In 1926, the Lafayette Parish School Board purchased Ile Copal, the former home of Gov. Alexandre Mouton, to house Paul Breaux School, the parish's only elementary school for blacks. During the Mississippi River flood of 1927, the grounds were used for a refugee camp for blacks from surrounding parishes. Note the tents in the background. Already in poor condition, the school burned down the following year.

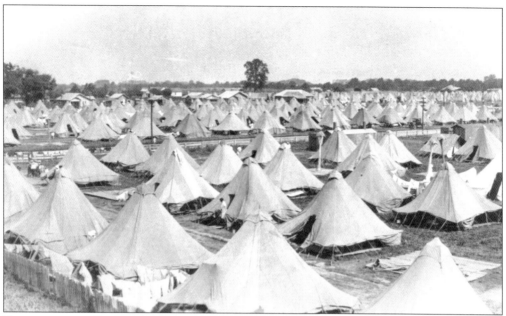

FLOOD OF 1927. Because Lafayette was situated on slightly higher ground, it escaped flooding during the Great Flood of 1927. Instead it became a refuge for flood victims from areas west of the Atchafalaya Basin. Southwestern Louisiana Institute closed so refugees could be housed in its buildings, and tent camps were established at several locations around town. Shown here is the camp at the fairgrounds.

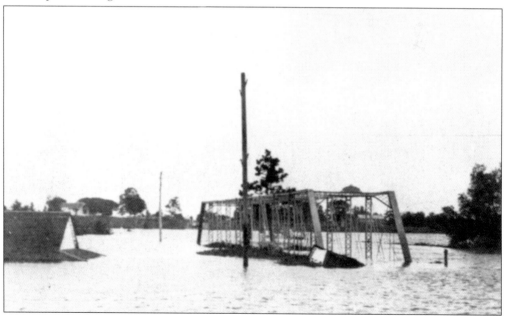

PINHOOK BRIDGE IN THE FLOOD OF 1927. The Vermilion River overflowed its banks, too, like so many other waterways in Louisiana. The land around Pinhook Bridge was inundated, but Lafayette remained dry and was able to shelter refugees from surrounding communities. Thus the decision of the voters in 1824, to locate the parish government at Vermilonville rather than at Pin Hook, was vindicated.

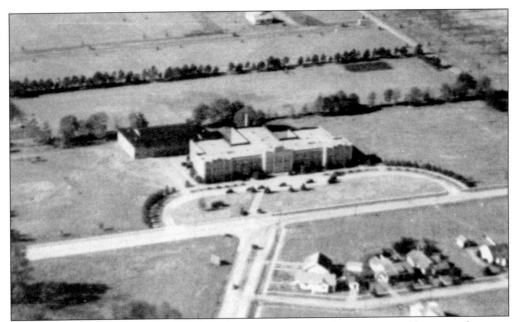

LAFAYETTE HIGH SCHOOL. As SLII phased out its preparatory department and became a four-year college, the public school system needed to expand its program and facilities to accommodate all of the high school students in Lafayette. A new high school was constructed on College (now University) Avenue and West Congress Street, on the edge of town. Today the building is four miles inside the city limits and houses Lafayette Middle School.

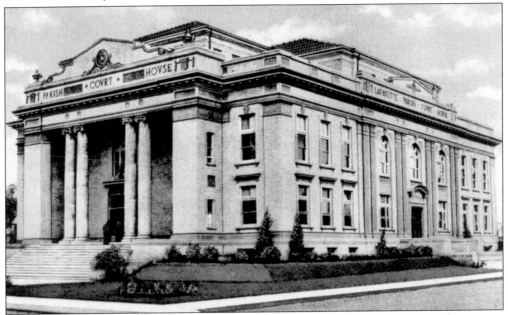

LAFAYETTE PARISH COURTHOUSE. In 1928, Lafayette Parish's antebellum courthouse was replaced by this imposing structure, designed by William T. Nolan and constructed by the General Contracting Company. Its builders expected it to last for centuries but did not anticipate the parish's rapid growth in the ensuing decades. The courthouse deteriorated quickly because of lack of maintenance and was demolished in 1965.

EVANGELINE HOTEL. When the Evangeline Hotel was built in 1932, it was the largest and finest hotel in the area. Its location near the railroad depot and the bus station made it popular with travelers. With the decline in downtown hotels, it was converted to offices for state government agencies in 1967 and now houses apartments for the elderly.

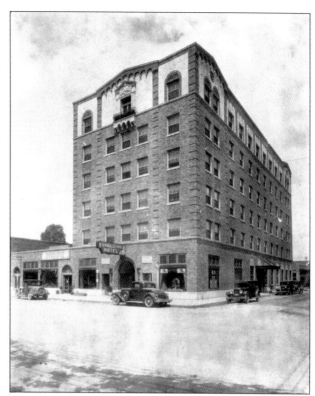

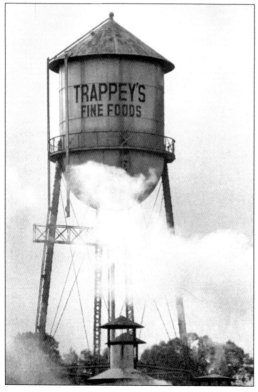

B. F. TRAPPEY'S SONS, INC. B. F. Trappey founded his hot sauce company in New Iberia in 1930 and soon expanded his operations to Lafayette. He developed a process for canning sweet potatoes in heavy syrup, which were marketed as candied yams. After World War II, the company expanded its product line with other foods seasoned to appeal to local tastes. The plant closed about 1990. (*Advertiser*; photograph by Donna Trahan.)

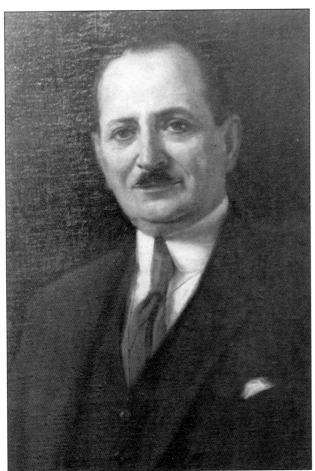

HENRI BENDEL. The founder of the New York fashion store that bears his name was a native of Lafayette. Although Bendel left the city as a young man to pursue his career, he returned often to visit family and friends. Later in life, he purchased a large estate on the outskirts of town in a bend of the Vermilion River, the old Walnut Grove plantation. There he cultivated azaleas and camellias. He planned to build an elaborate home there but never got beyond a house he called Camellia Lodge that he used as a summer home. This estate was later developed as a residential area, Bendel Gardens, featuring winding streets and spacious homes on rolling hills formed by the river. Below is Camellia Lodge.

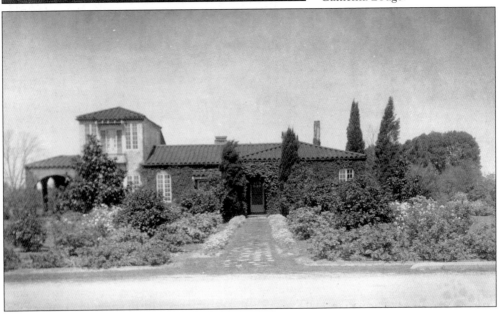

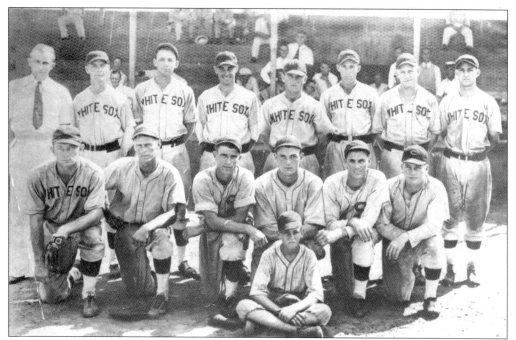

EVANGELINE LEAGUE BASEBALL. Minor league baseball was a popular pastime throughout the country in the mid-20th century. The Evangeline League played class D baseball in Louisiana and adjacent areas of Texas and Mississippi between 1934 and 1957. Lafayette was home to three teams: the White Sox before World War II, the Bulls after the war, and the Oilers in the mid-1950s. Shown here are the White Sox of 1934.

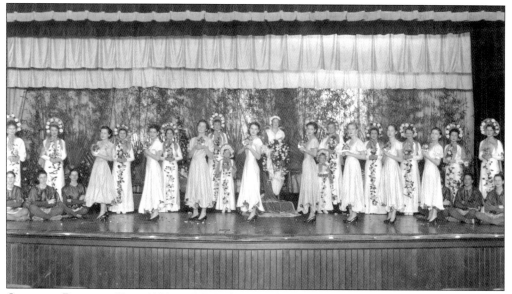

CAMELLIA PAGEANT. From 1934 to 1962, Lafayette celebrated the Camellia Pageant in conjunction with the Mid-Winter Fair. Camellias were just beginning to be popular as a commercial crop, and the pageant was intended to help publicize the flower. SLI coeds were chosen to be the queen and her maids. The pageants, staged by the college, included elaborate musical and dance productions that drew audiences numbering in the thousands.

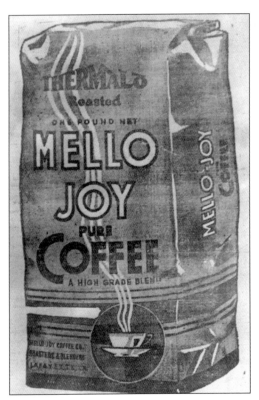

MELLO JOY COFFEE. Mello Joy Coffee was founded by brothers Louis and Will Begnaud in 1936 and was a fixture in Lafayette for nearly four decades. The company was sold to Community Coffee in 1975, which gradually phased out production of the Mello Joy blend. In 2000, Louis's grandson Brian Begnaud resurrected the name, the blend, and the distinctive yellow label, to the delight of coffee drinkers throughout Acadiana.

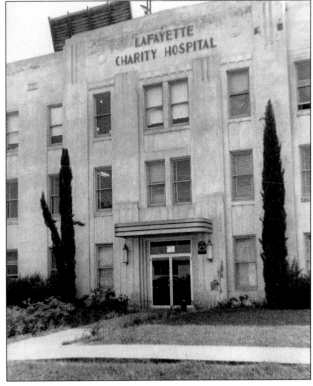

LAFAYETTE CHARITY HOSPITAL. In 1937, the state opened Lafayette Charity Hospital, the first unit of Huey Long's plan to "take the hospital to the patients, not the patients to the hospital." Previously, the only state hospitals were located in New Orleans and Shreveport. Lafayette Charity Hospital provided free medical care to the poor of Acadiana and trained nursing students from SLI and Lafayette Technical School. (*Advertiser*; photograph by Ross Heard.)

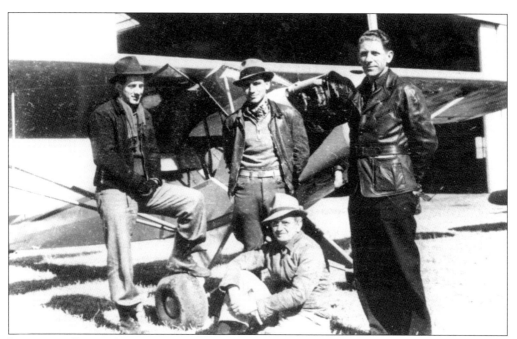

LAFAYETTE FLYING SERVICE. Aviation piqued local interest in the years leading up to World War II. Leo Gros operated the Lafayette Flying Service at Girard Field north of Lafayette on Highway 182, where many young men and women learned to pilot airplanes. Pictured here are, from left to right, (seated) Frenchie Fortune; (standing) F. H. Foreman, Robert Meyer, and Leo Gros.

AMBASSADOR JEFFERSON CAFFERY. A native of Lafayette, Jefferson Caffery joined the diplomatic corps in 1911. During his 44-year career, he served in posts all over the world, including such trouble spots as Brazil (1937–1944), France (1944–1949), and Egypt (1949–1955). He was known as a diplomat's diplomat for his even-handed, pragmatic style and his success in attaining American goals. He returned to Lafayette after his retirement and died here in 1974.

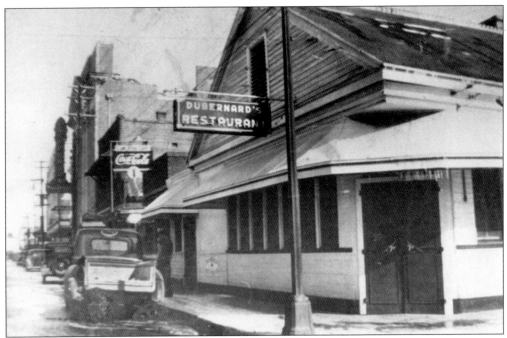

DuBernard Restaurant. Around 1940, the duBernard family opened a restaurant in their meat market on the corner of Jefferson and East Main Streets. During World War II, the army induction center was located in the Southside School across Main Street from the restaurant, and the duBernards made all servicemen welcome at the restaurant regardless of their ability to pay for their meals. The restaurant became the Blair House in 1950.

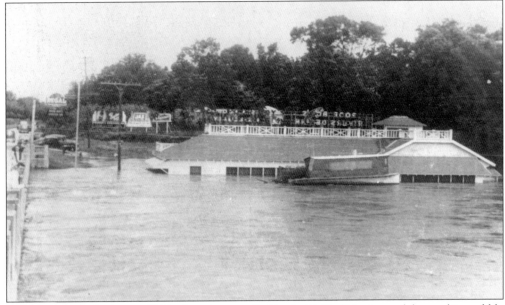

Flood of 1940. In August 1940, a hurricane stalled in the Gulf of Mexico and dumped incredible amounts of rain on southwest Louisiana, causing widespread flooding. In one 24-hour period, August 8–9, Lafayette received nearly 20 inches of rain. Some streets had water 6 feet deep, and Riverside Inn on the bank of the Vermilion River near Pin Hook Bridge took in 10 feet of water.

Four

POSTWAR GROWTH

OUR LADY OF LOURDES HOSPITAL. In 1945, Msgr. A. F. Isenberg of Lafayette was injured in an automobile accident and taken to Our Lady of the Lake Hospital in Baton Rouge. He was so impressed with the care he received there that he urged the Franciscan Missionaries of Our Lady to open a similar facility in Lafayette. Our Lady of Lourdes opened in 1949, with 50 beds plus 15 bassinets for infants.

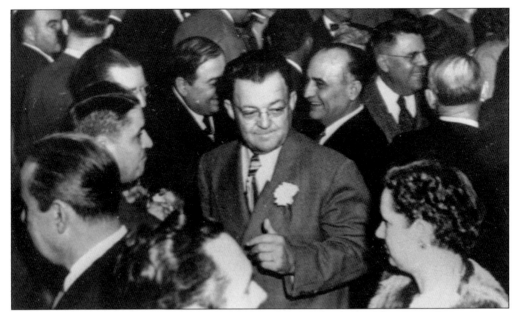

DUDLEY LEBLANC. Dudley LeBlanc was a politician, bilingual radio broadcaster, and entrepreneur. During his long career, he served in the state legislature and on the Public Service Commission, but his greatest ambition was to be governor. He was proud of his Acadian heritage, wrote three books on Acadian history, and worked to instill a similar pride in his constituents. Throughout his career, he was always a friend of the poor.

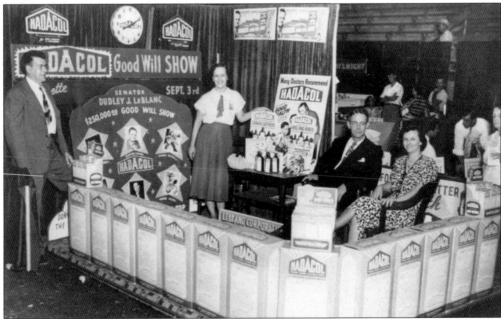

HADACOL. Between 1945 and 1952, Dudley LeBlanc put Lafayette on the map with his tonic Hadacol, a foul-tasting mixture of B vitamins, iron, calcium, citric acid, alcohol, and honey. LeBlanc was a genius at promotion, and through massive advertising campaigns that included radio, television, newspapers, billboards, in-store displays, and the sensational Hadacol Goodwill Caravan, he created more demand for the product than his factories could produce.

HADACOL CARAVAN. The high point of Dudley LeBlanc's promotional efforts was the Hadacol Caravan, billed as "The Greatest Medicine Show on Earth." For the admission price of one Hadacol box top, attendees saw a variety show featuring movie stars, comics, vaudeville acts, singers, jazz bands, and dancing girls. LeBlanc is shown here with some of the performers, including Minnie Pearl (top row center), Jack Dempsey and Cesar Romero (bottom row left), and Rudy Vallee (bottom row right).

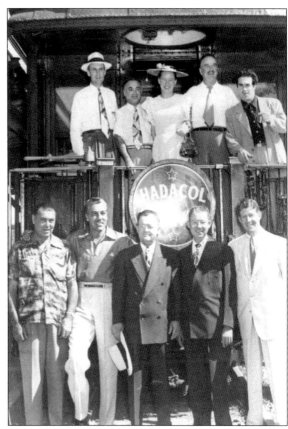

HADACOL PLANT. Hadacol was marketed throughout the South and out to the West Coast as an effective treatment for a variety of ailments. At the height of its popularity, Hadacol was produced in six plants, which employed as many as 370 workers in shifts around the clock. The business was always underfinanced, and LeBlanc sold out in 1951 to run for governor. The new owners declared bankruptcy soon afterwards.

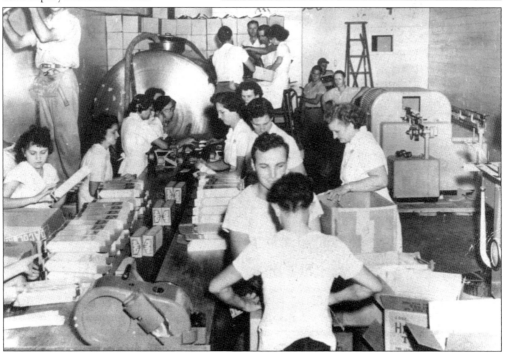

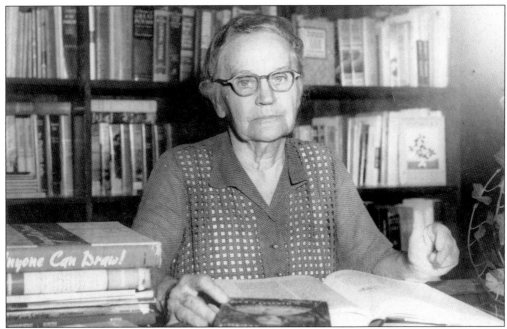

EDITH GARLAND DUPRÉ. Edith Garland Dupré was a member of the first faculty at SLII and taught there until retiring in 1944. She was a much-loved teacher and an active member of the community, serving as chair of the Women's Defense League during World War II, helping form the public library system, and working to preserve oak trees in town. After retiring, she opened Sans Souci Bookstore in downtown Lafayette.

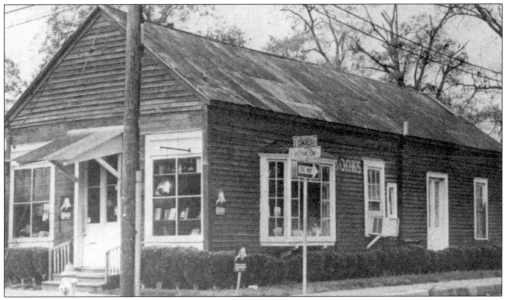

SANS SOUCI BOOKSTORE. At various times, this little building has housed a post office, inn, tinsmith's shop, shoe repair shop, pecan merchant, saddle shop, sandwich shop, and residence, but it is best known as the Sans Souci Bookstore, the book and antique store founded by Edith Garland Dupré. Here she presided over book signings and literary gatherings, continuing her life's work of promoting love of learning and good books.

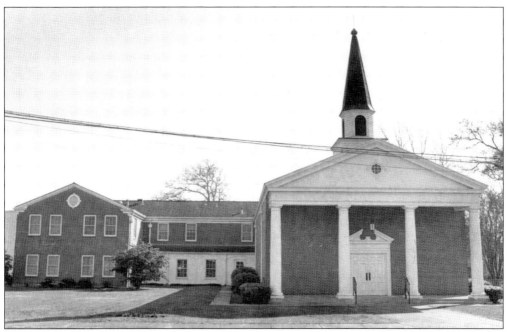

FIRST BAPTIST CHURCH. Designed by noted architect A. Hays Town and constructed by Horace B. Rickey Sr., this building stood on the corner of Lee Avenue and Barry Street. It was dedicated in 1949 and enlarged in 1971, as the congregation doubled in size. A fire destroyed the sanctuary in 1999, but the steeple and the pillars flanking the doorway were salvaged to be used in the new facility.

LAFAYETTE MEDICAL SURGICAL GROUP. What had been an informal partnership of doctors who shared offices near the Lafayette Sanitarium in the 1920s became the Lafayette Medical Surgical Group in 1948. Under the leadership of Dr. C. E. Hamilton, the group continued to grow, incorporating as the Hamilton Medical Group in 1971. Later the group built Hamilton Medical Center, now known as the Medical Center of Southwest Louisiana.

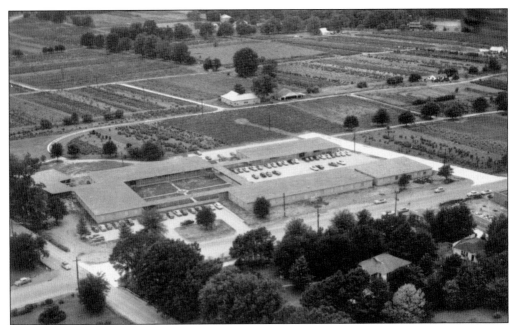

LAFAYETTE OIL CENTER. As the oil industry grew after World War II, Maurice Heymann recognized the need for more office space in Lafayette and began constructing the Oil Center on land previously used for a nursery. At the height of the oil boom, the center was home to nearly 500 oilfield-related businesses, as well as retail stores, restaurants, a motel, a post office, Lafayette General Hospital, and the Petroleum Club.

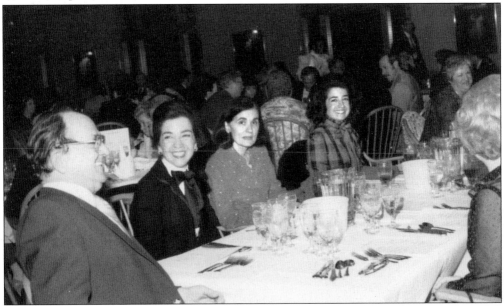

PETROLEUM CLUB. In 1952, Maurice Heymann donated the land in the Oil Center for a club where oilmen could relax, socialize, and discuss business, and the Petroleum Club of Lafayette was formed. The club expanded quickly and at the height of the oil boom was the largest petroleum club in the world. Membership was opened to women in 1982 and to members outside the oil industry in 1986. (John Stephan.)

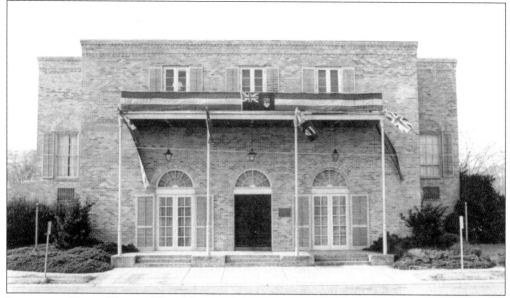

LAFAYETTE TOWN HOUSE. The oldest private club in Lafayette began as the Spanish Lake Club in 1941. After World War II, it moved to downtown Lafayette and was renamed the Town House Club. It was a center of business and social life for its members, and its Mardi Gras Ball, begun in 1953, was the most prestigious ball in town. In 1968, the club constructed this building on Auditorium Place.

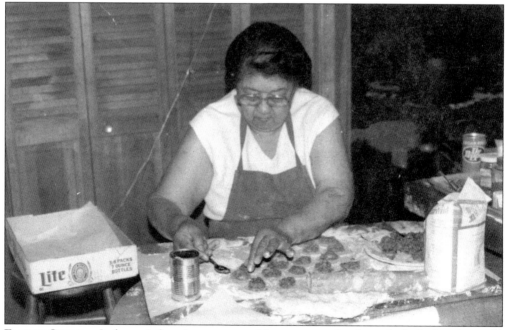

FANNIE CORNAY. Lafayette's favorite caterer could not write and only read a little, but she could cook. All her recipes were in her head, and she never measured her ingredients. From 1950 to 1975, she was the Lafayette Town House Club's cook, famous for her meat pies, ribbon sandwiches, and other delicacies. Family members and friends recorded her recipes for her and published her cookbook after her death. (*Advertiser.*)

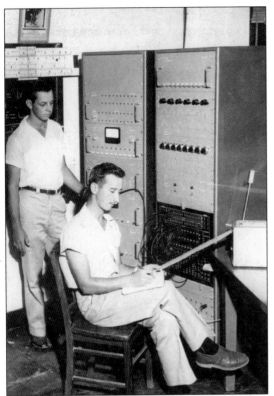

ELECTRONIC BRAIN AT SLI. Computers were in their infancy when SLI acquired its first analog computer in 1954. The control panel resembled a telephone switchboard; results were written on a moving graph by an electronic pen. Besides being used for mathematics instruction, it was made available to business, industry, and the professions in the area. Here students Sammy Fontenot and Irving Manuel study a printout from the machine.

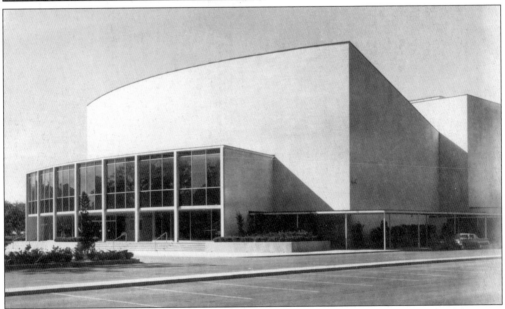

MUNICIPAL AUDITORIUM. In the late 1950s, civic leaders began a campaign to build a civic auditorium. Designed by A. Hays Town, the auditorium was one of the largest in the South, with a 56-foot proscenium, an orchestra pit, and seating for 2,500 in the auditorium, plus a banquet hall. In 1989, the auditorium was remodeled and rededicated to Maurice and Herbert Heymann, who were instrumental in its being built.

ED ABDALLA. The son of George Abdalla, a Lebanese immigrant who owned a clothing store in Opelousas, Ed Abdalla opened Abdalla's of Lafayette in 1933. Besides his business interests, he was also active in community affairs, particularly the chamber of commerce, United Givers Fund, Boy and Girl Scouts, American Legion baseball, and Lafayette Parish 4-H. Abdalla's sponsored the annual Christmas parade in Lafayette until 2005.

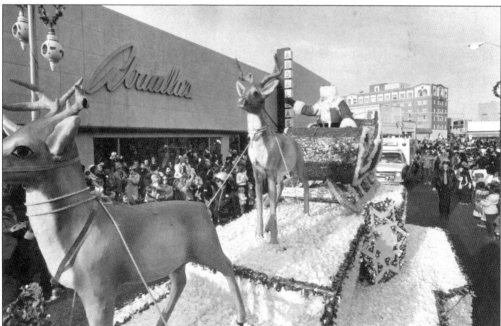

ABDALLA'S CHRISTMAS PARADE. The Lafayette Christmas parade, begun by the chamber of commerce about 1950, was sponsored by Abdalla's Department Store for more than 30 years. In the beginning, the parade followed Jefferson Street through downtown, then the route was extended to Jefferson and Pinhook to accommodate the crowds. In recent years, the parade, now sponsored by Sonic Drive-Ins, has begun in the Oil Center and ended downtown. (*Advertiser.*)

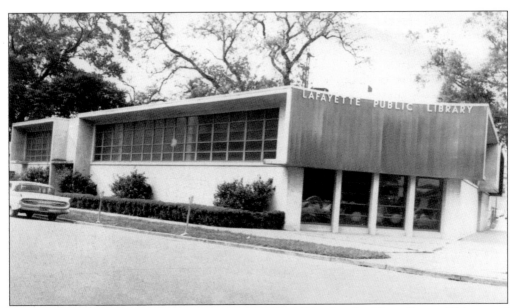

LAFAYETTE PUBLIC LIBRARY. Library services began in 1932, when Les Vingt Quatre Club started a lending service for children with 50 books in a bookcase in the courthouse. The library later occupied space in the old Southside School building, then the old city hall before this building was built in 1953. Now known as Maison des Arts, it houses the Acadiana Arts Council and other community arts organizations.

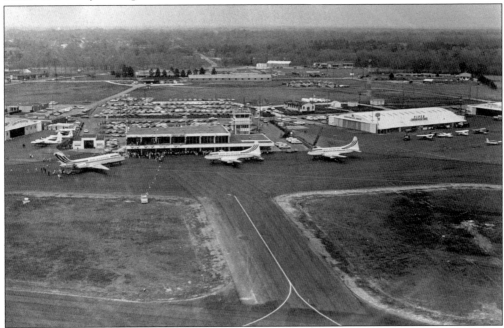

LAFAYETTE MUNICIPAL AIRPORT. Aviation came to Lafayette in 1929 when the city established an airfield on the old Beau Sejour plantation across the Vermilion River southeast of town. When the field was used for military training during World War II, the federal government constructed hangars and barracks there and paved the runways. Regular commercial passenger service began in 1946, and this terminal building was constructed in 1957.

JAY AND LIONEL HEBERT. The Hebert brothers learned to play golf while caddying at the Municipal Golf Course as teenagers. They joined the professional golf tour after serving in the military during World War II. Lionel (right) won the PGA Championship in 1957 and Jay (left) in 1960, making them the only brothers to do so. The course has been named the Jay and Lionel Hebert Municipal Golf Course in their honor.

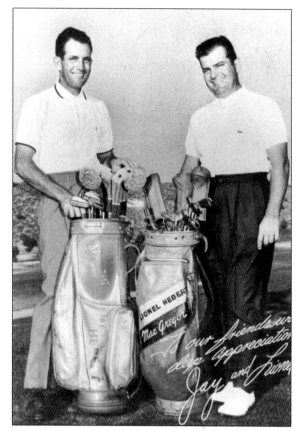

FIRST CHURCH OF CHRIST, SCIENTIST. Christian Scientists began meeting in Lafayette in 1928 and two years later built a small church on Voorhies Street. In 1931, they received a charter as a Christian Science Society. By 1959, the group had grown large enough to purchase this building on Acadian Drive, and in 1965, it became the First Church of Christ, Scientist, Lafayette. The auditorium was added in 1979. (*Advertiser.*)

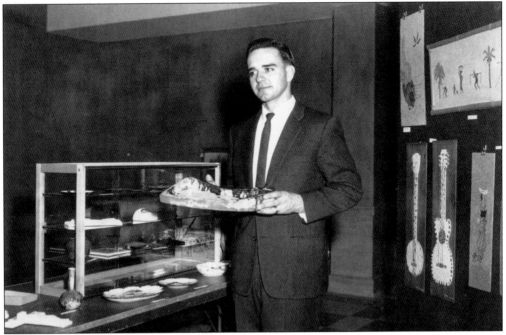

LAFAYETTE ART ASSOCIATION. Organized to support and encourage the visual arts and crafts, as well as artists and craftsmen, the Lafayette Art Association held its first arts and crafts show in 1959. Shown here is Gordon H. Blake, the association's first president, with some of the clay pieces he exhibited at that show. (*Advertiser.*)

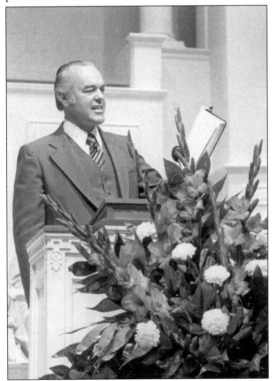

REV. PERRY SANDERS. A native of South Carolina, Perry Sanders served as pastor of First Baptist Church from 1959 to 2006. It was a period of remarkable growth. His televised services, begun in 1963, made him a familiar face throughout the Lafayette area and beyond. A powerful speaker and a dynamic leader, Reverend Sanders has been active in religious and community circles for nearly half a century. (*Advertiser.*)

PAUL FOURNET AIR SERVICE. Paul Fournet learned to fly in the Army Air Corps during World War II, piloting P-38s on reconnaissance missions in the Pacific theater. After the war, he established Paul Fournet Air Service at the Lafayette Regional Airport, which became one of the largest fixed-base operations in the state. He is shown here with his wife, Ruby, celebrating 30 years in business. (*Advertiser*.)

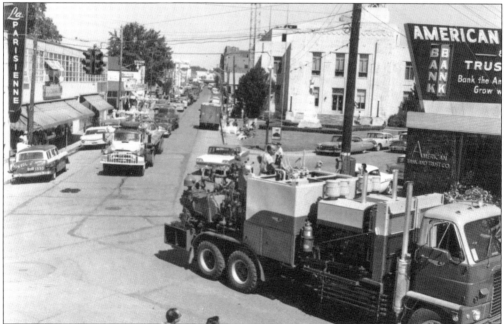

LAGCOE PARADE, 1959. The Louisiana Gulf Coast Oil Exposition (LAGCOE) is a "working man's oil show" held every other year since 1955. One outstanding member of the industry is chosen as LAGCOE Looey, who presides over the show. Volunteers from local drilling, production, and service companies did all the work of putting on the exposition until 1980. Today it is one of the two largest petroleum industry conferences in the United States.

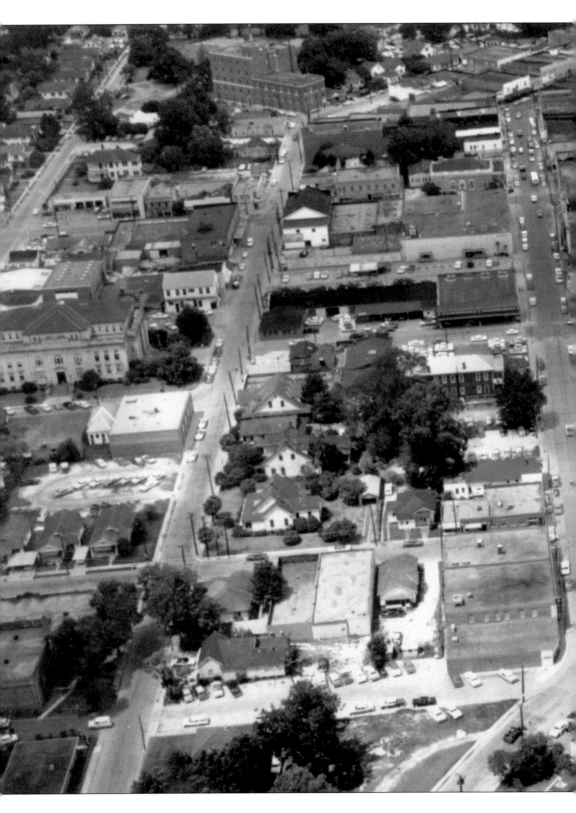

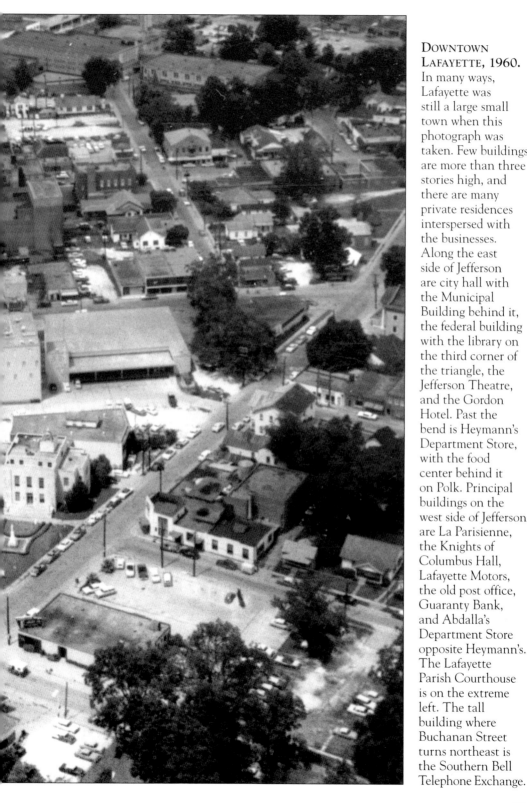

DOWNTOWN LAFAYETTE, 1960. In many ways, Lafayette was still a large small town when this photograph was taken. Few buildings are more than three stories high, and there are many private residences interspersed with the businesses. Along the east side of Jefferson are city hall with the Municipal Building behind it, the federal building with the library on the third corner of the triangle, the Jefferson Theatre, and the Gordon Hotel. Past the bend is Heymann's Department Store, with the food center behind it on Polk. Principal buildings on the west side of Jefferson are La Parisienne, the Knights of Columbus Hall, Lafayette Motors, the old post office, Guaranty Bank, and Abdalla's Department Store opposite Heymann's. The Lafayette Parish Courthouse is on the extreme left. The tall building where Buchanan Street turns northeast is the Southern Bell Telephone Exchange.

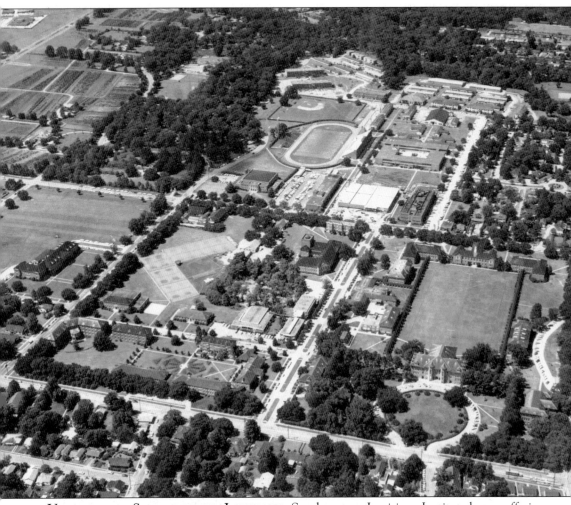

UNIVERSITY OF SOUTHWESTERN LOUISIANA. Southwestern Louisiana Institute began offering graduate degrees in the 1950s, and in 1960, it was granted university status and a new name. The University of Southwestern Louisiana (USL) was organized into six undergraduate colleges: Liberal Arts, Education, Agriculture, Engineering, Nursing, and Commerce, plus the Graduate School. The campus continued to expand to accommodate an enrollment of 5,000 students, double the number of a decade earlier. Martin Hall faces the circle on the lower right with the quadrangle behind it. Women's dormitories and the rose garden are on the lower left. Cypress Lake is near the center of the photograph, with Burke Hall just beyond. Across St. Mary Boulevard between the biology and chemistry buildings is the Dupré Library, just a one-story building in the early 1960s. McNaspy Stadium is near the top center of the photograph. Men's dormitories are at the extreme top center, with married student housing to the right. Girard Park is the wooded area near the upper left. Beyond it is Maurice Heymann's nursery.

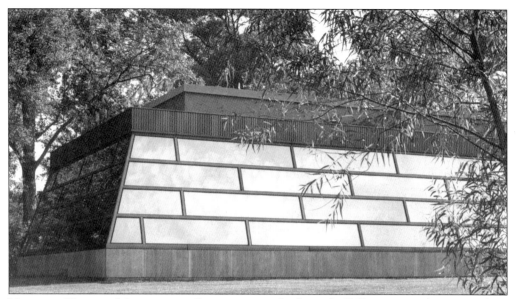

NATURAL HISTORY MUSEUM AND PLANETARIUM. In the early 1960s, a group of young mothers conceived the idea of a youth museum and planetarium to educate and entertain their children. This modern glass building, on land near the Oil Center donated by Maurice Heymann, was the result. The museum offered spaces for rotating exhibits, a gift shop, a planetarium, and one of the few basements in Lafayette. (*Advertiser.*)

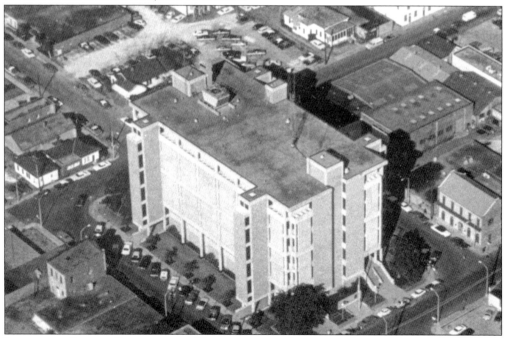

LAFAYETTE PARISH COURTHOUSE. The present courthouse was designed by Don J. O'Rourke and constructed by Horace B. Rickey, Inc., in 1965. Seven stories tall and filling the courthouse square, it nonetheless has proved insufficient to contain the rapidly expanding parish government. The Sheriff's Department Office, the Parish Jail, and the Lafayette Parish Government Building have been built in recent years to house other government functions.

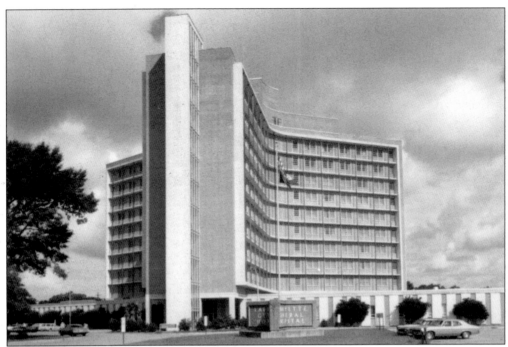

LAFAYETTE GENERAL HOSPITAL. The Lafayette Sanitarium outgrew its location on St. John Street, moved to the Oil Center, and was renamed the Lafayette General Hospital. Maurice Heymann donated land at the corner of Coolidge Boulevard and South College Road, plus $50,000 in cash. The seven-story building, with capacity for 300 beds, opened in 1965 and was increased to 11 stories and over 400 beds four years later. (John Stephan.)

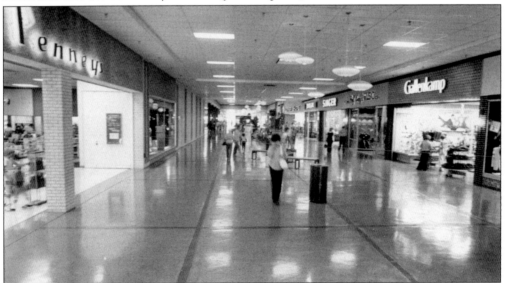

NORTHGATE MALL. Lafayette's first enclosed shopping mall, Northgate Mall, opened in 1965 with 37 stores, anchored by Montgomery Wards and J. C. Penney department stores. Retailers benefited from the mall's location near the intersection of Highway 167 and Interstate 10, which made it easily accessible to shoppers from surrounding communities as well as Lafayette residents. (*Advertiser.*)

ACADIAN FLAG. Commissioned by France-Amérique de la Louisiane Acadienne and designed by Dr. Thomas Arceneaux in 1965, the Acadian flag features three silver fleur-de-lis on a blue field, symbolizing the Acadians' French heritage; a gold castle on red, symbolizing Spanish rule in Louisiana, during which the Acadians were encouraged to settle here; and a gold star on white, representing Our Lady of Assumption, patron saint of the Acadians. (*Advertiser.*)

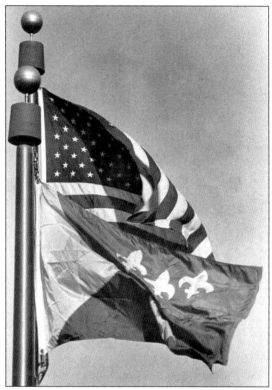

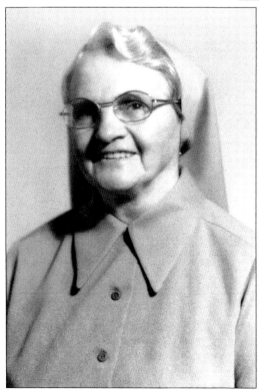

SR. AGNES MARIE FITZSIMMONS. A native of Northern Ireland, Sister Agnes Marie came to Lafayette in 1966 as administrator of Our Lady of Lourdes Hospital. During her 17 years' leadership, Lourdes grew from 160 to 430 beds and became a regional diagnostic center, instrumental in making Lafayette the center of medical care for Acadiana. Mayor Dudley Lestrapes declared May 24, 1983, "Sister Agnes Marie Fitzsimmons Day." (*Advertiser.*)

BOB ANGERS. Formerly the owner and editor of the Franklin *Banner-Tribune*, Bob Angers joined the editorial staff of the Lafayette *Advertiser* in 1966. Shortly afterwards, he founded *Acadiana Profile*, a bimonthly magazine presenting feature stories on topics of regional interest. He was a tireless promoter of good government and community betterment programs and was active in journalism and international relations organizations.

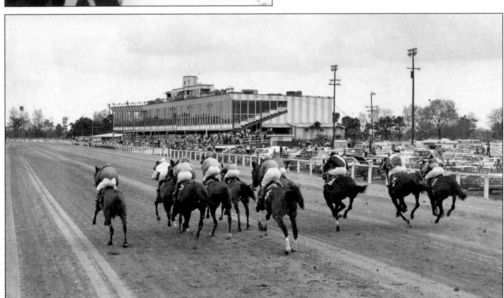

EVANGELINE DOWNS. Horse racing had long been popular in south Louisiana when Evangeline Downs opened near Lafayette in 1966. Races began with the call of "Ils sont parties!" (They're off!) A number of legendary jockeys began their careers there, including Eddie Delahoussaye, Kent Desormeaux, Randy Romero, and Ray Sibille. After Louisiana legalized other forms of gambling, horse racing lost some of its allure. Evangeline Downs moved to St. Landry Parish in 2005.

JAMES DOMENGEAUX. Attorney, politician, and leader of the French cultural renaissance, Jimmy Domengeaux founded the Council for the Development of French in Louisiana, or CODOFIL, in 1968. As its chairman for nearly 20 years, he worked tirelessly to promote the study of the French language in Louisiana schools and its use in everyday life, as well as supporting activities to nurture Francophone literature, music, and other cultural elements.

COUNCIL FOR THE DEVELOPMENT OF FRENCH IN LOUISIANA. Established by the State Legislature in 1968 to "do any and all things necessary to accomplish the development, utilization and preservation of the French language as found in Louisiana," CODOFIL has sponsored education, international exchanges, and community outreach programs to promote the everyday use of the French language in Louisiana. Here an advisory council meets to discuss bilingual career education.

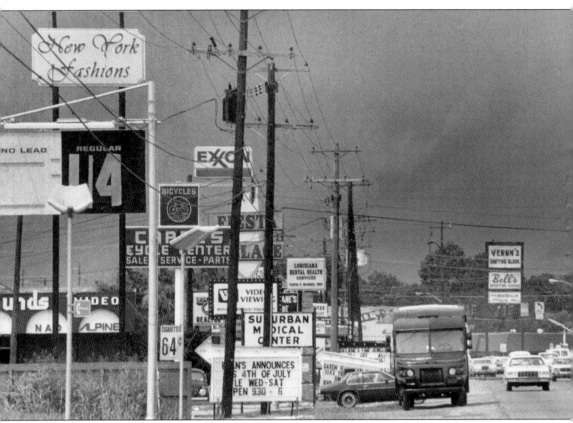

JOHNSTON STREET. Johnston Street, carrying Highway 167 through Lafayette on the way to Abbeville, became a major commercial corridor after World War II as small businesses and strip malls sprouted up along its route. The proliferation of business signs and the congested traffic have long been problems, but periodic efforts at traffic control and beautification have had limited success. (*Advertiser.*)

Five

BOOM AND BUST

THE VEGETABLE MAN. Leo Caillier was a familiar sight around Lafayette for nearly 70 years, selling homegrown produce from his horse-drawn wagon. Uneducated but strongly principled and a leader in the black community, he was so well respected he was chosen to serve as marshal for the 1984 Centennial Parade. Emphasizing self discipline and a positive attitude, he saw that his children received a thorough education.

ACADIAN AMBULANCE SERVICE. In 1971, Richard Zuschlag, Roland Dugas, and Richard Sturlese incorporated Acadiana Ambulance Service to provide emergency transportation in the Lafayette area. Prior to this, funeral homes had transported accident victims to hospitals. Since then, the company has grown from eight medics, all Vietnam War veterans, and two ambulances to the largest ambulance company in the United States with over 2,000 employees, 200 ambulances, and 11 aircraft. (*Advertiser.*)

PETROLEUM HELICOPTERS, INC. As the oil exploration pushed into the swamps of south Louisiana, Jack Lee conceived the idea of using helicopters to transport crews to remote areas. Soon Petroleum Helicopters, Inc., began ferrying crews to offshore drilling platforms as well. PHI is now one of the largest commercial helicopter companies in the world, serving the offshore oil industry in 44 countries with an outstanding record of safety. (John Stephan.)

SACRIFICING TREES. Many of Lafayette's residential streets have been shaded by rows of live oak trees. As the population grew and automobiles became the principal means of transportation, some streets have needed to be converted to arteries to handle the increased traffic. In order to widen those streets, their oaks had to be removed. Here a tree on East Pine Street near Northgate Mall falls victim to progress. (*Advertiser.*)

JUVENILE DETENTION HOME. Lafayette's Juvenile Detention Home, opened in 1972, quickly became ranked among the best in the nation. Its staff members were required to take annual training courses and were praised for their dedication. The facility on Surrey Street provided its residents psychological testing, medical care, religious services, and extracurricular activities as well as an educational program through the parish school system. (*Advertiser.*)

OLLIE OSBORNE. Community activist Ollie Tucker Osborne had a successful career in publishing and public relations in New York before coming to Lafayette. She was involved in many political and women's rights organizations, including the League of Women Voters and Equal Rights Amendment movement, and helped plan several statewide conferences on women. Her newspaper articles on Louisiana's 1973 Constitutional Convention were widely published and influenced the passage of the new constitution.

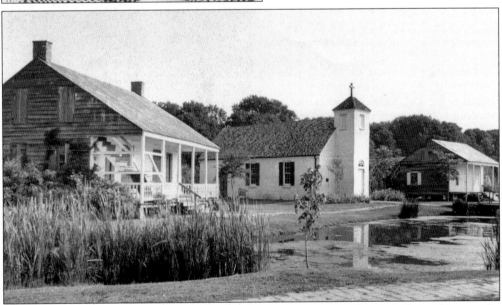

ACADIAN VILLAGE. In an effort to increase tourism in Lafayette, and to provide employment for people with developmental disabilities, the Lafayette Association for Retarded Citizens transformed 10 acres of farmland into a typical c. 1800 Cajun village. Seven 19th-century houses from around Acadiana were donated, moved, and restored, and other period buildings were replicated. Pictured from left to right are the Billeaud House, New Hope Chapel, and the Castille House.

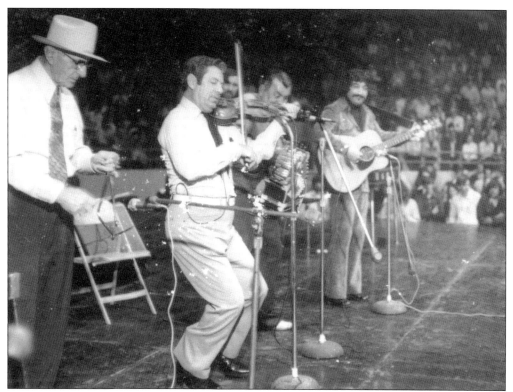

TRIBUTE TO CAJUN MUSIC. In May 1974, CODOFIL sponsored the Tribute to Cajun Music, a concert at Blackham Coliseum, to recognize a style of music that had deep cultural roots in south Louisiana but had seemingly fallen out of favor. Despite bad weather, the coliseum was filled to overflowing, and the program was such a success that it became an annual event, evolving into part of Festivals Acadiens.

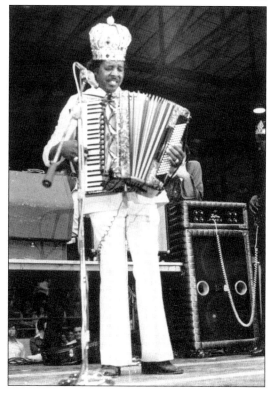

THE KING OF ZYDECO. Clifton Chenier, with his brother Cleveland, took the old dance music of rural Louisiana Creoles and added blues, soul, and country elements to create zydeco. He recorded over 100 albums and played music festivals throughout the United States and Europe. Later in his career, he was billed as the King of Zydeco and began his appearances wearing an ornate crown. (*Advertiser.*)

MICHAEL DOUCET. Fiddler Michael Doucet and his band Beausoleil have been instrumental in popularizing Cajun music since the band's formation in 1975. He learned traditional Cajun songs from older Cajun and Creole masters such as Dewey Balfa, Dennis McGee, and Canray Fontenot, but Doucet added elements from contemporary styles such as rock, jazz, and R&B to expand the music's boundaries while celebrating its heritage. (*Advertiser.*)

ROBERT DAFFORD. Internationally known mural artist Robert Dafford painted his first murals in Lafayette. Outdoor art, he believed, would make art a part of the public's daily life. He is shown here in front of an Acadian landscape he painted in 1978 on the side of the Lee Furniture building downtown at the corner of Jefferson and Garfield Streets, one of several murals he has painted in Lafayette. (*Advertiser.*)

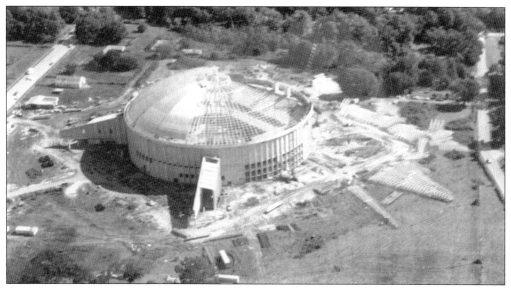

CAJUNDOME UNDER CONSTRUCTION. The Municipal Auditorium proved too small to attract large conventions, concerts, and sporting events. By the mid-1970s, civic leaders began exploring ideas to build a multipurpose civic center to meet the needs of the growing community. Designed by Lafayette architect Neil Nehrbass, the Cajundome was built with state and city funds on land owned by the university and is managed by the city.

ACADIANA PARK NATURE STATION. Opened in 1978 as a branch of the Lafayette Natural History Museum, the Nature Station in Acadiana Park features exhibit space, a classroom, work and office space, and three miles of paths through the surrounding woods. Within the 110-acre site, visitors can see three major habitat types: bottomland hardwood forest, a transitional oak/hickory forest, and a tall-grass prairie. (*Advertiser.*)

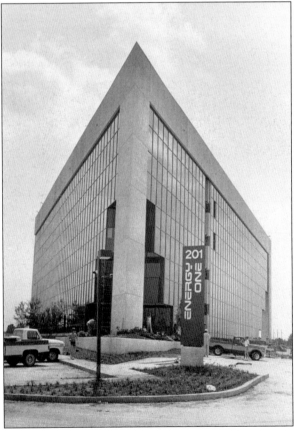

MARGARET MCMILLAN. As the offshore oil industry grew, Margaret McMillan, an avid swimmer, recognized the need to train offshore workers in water safety and emergency survival. Forming her own company, McMillan Offshore Survival Technology, McMillan pioneered programs that have been credited with saving thousands of lives by teaching workers how to survive in the water, how to use safety equipment, and how to react in emergencies. (*Advertiser.*)

REAL ESTATE BOOM. The tremendous growth in the oil business during the 1970s led to a construction boom in office space as well. Shown here is Energy One, a striking three-sided office building on Energy Parkway near Pinhook Road. Five stories tall plus a basement, it was part of the more than two million square feet of office space constructed between 1979 and 1981. (*Advertiser*; photograph by Ross Heard.)

MARDI GRAS. Mardi Gras in Lafayette is smaller and more family-oriented than in New Orleans but just as much fun. Since 1934, the Southwest Louisiana Mardi Gras Association has sponsored a citywide Mardi Gras celebration in Lafayette, ruled over by King Gabriel and Queen Evangeline. The festivities have grown to include six parades between Friday evening and Tuesday afternoon. Other activities include a costume contest, carnival rides, and concerts. Carnival organizations such as the Lafayette Town House Order of the Troubadours, ruled over by King Richard Coeur de Lion and Queen Berengaria of Navarre, also stage elaborate pageants for their members. In recent years, the pageants of the Krewe of Apollo have become especially popular.

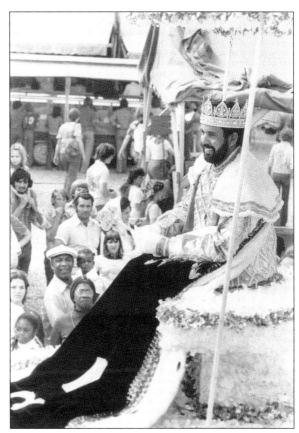

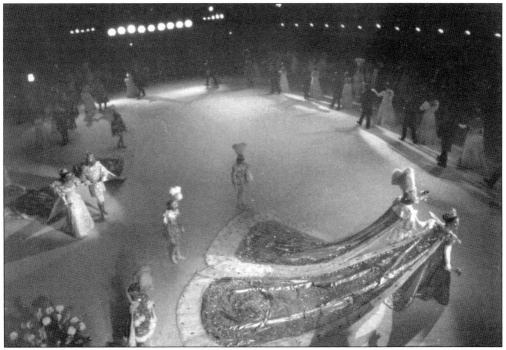

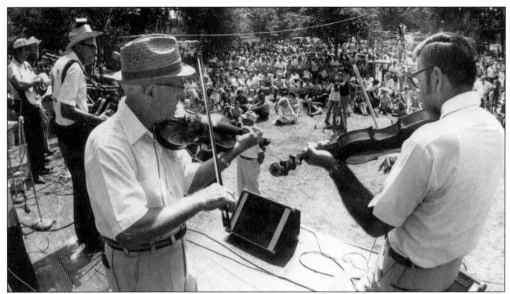

FESTIVALS ACADIENS. The Tribute to Cajun Music was such a success that it became a yearly event and joined with the Natural History Museum's Native Crafts Festival and the Lafayette Jaycees' Bayou Food Festival to form Festivals Acadiens, a three-day event celebrating the Cajun culture of southwest Louisiana. The festivities begin each fall with Downtown Alive's opening concert on Friday night and continue with two more days of music, dancing, food, and crafts in Girard Park. The music festival focuses on traditional Cajun and Creole music, while the crafts festival features both traditional native crafts and contemporary crafts. Local restaurants set up booths around the park where they offer selections of local delicacies such as boudin, jambalaya, and bread pudding as well as tasty dishes of their own creation.

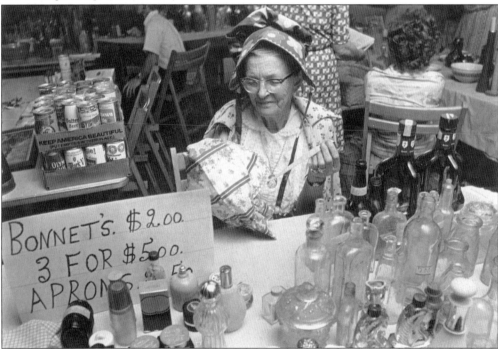

GRANT STREET DANCEHALL. In 1980, Pat Henisee and Mike Farmer took an old brick-and-cypress produce warehouse downtown near the railroad tracks and transformed it into the Grant Street Dancehall, where locals could hear and dance to good music. Their knack for booking national acts on the rise and popular local bands soon made the dance hall legendary. Subsequent owners have continued the tradition. (*Advertiser*; photograph by G. G. Sierveld.)

FOOD DRIVE. Members of the Torch Club, a branch of the Boys' Club, collected donations of food and other household items for the needy as their fall project in 1981. Here members of the club are shown preparing boxes of food and household items to take to families in their neighborhoods at Thanksgiving time. (*Advertiser*.)

ERNEST J. GAINES. From 1983 to 2005, Ernest Gaines was professor of English and writer in residence at the University of Louisiana at Lafayette. Gaines has published six novels, including *The Autobiography of Miss Jane Pittman* and *A Lesson Before Dying*, a collection of short stories and a collection of essays respectively. His books, which have won numerous awards, subtly portray the effects of racism and injustice in the rural South.

ACADIANA SYMPHONY. In the early 1980s, USL music professor Allan Dennis organized L'Orchestre, an amateur musical group of about 50 members, half USL students and the rest members of the Lafayette community: high school students, teachers, retirees, businessmen, laborers, and clergy. Over time, the symphony grew and evolved to become the Acadiana Symphony Orchestra, a professional regional orchestra that has earned regional and national recognition. (*Advertiser.*)

Hospice of Acadiana. The oldest hospice organization in Louisiana, Hospice of Acadiana was incorporated in 1983 and began providing patient care the following year. As a nonprofit organization, Hospice provides home-based palliative care to the terminally ill regardless of the ability to pay. Shown here from left to right are the members of the first board of directors: Nancy Whittington (seated), Jewell Lowe, Rev. Louis Richard, and Dr. Louis Buettner. (*Advertiser.*)

St. Joseph Diner. A service of the Diocese of Lafayette, St. Joseph Diner was dedicated by Bishop Gerald Frey and Msgr. A. O. Segur in 1983. The diner serves an average of 200 free breakfasts and lunches each day. Volunteers also deliver meals to the homebound, bread and other foodstuffs to the elderly, and holiday baskets to low-income households. All the food is donated, and volunteers prepare the meals. (*Advertiser.*)

CENTENNIAL CELEBRATION. The city observed the 100th anniversary of its being named Lafayette with a year-long celebration that included parades, festivals, museum exhibits, tours of historic homes and sites, and other programs. There were boat parades on the Vermilion River to begin the celebration and to open the final week of activities. Publications commemorating the event included supplements in the *Daily Advertiser*, a book on historic buildings, a cookbook, and a coloring book. Events culminated May 4 and 5, 1984, with a parade down Johnston Street, a fais-do-do and fireworks at Cajun Field, and festival featuring music, crafts, and food at Girard Park. (*Advertiser.*)

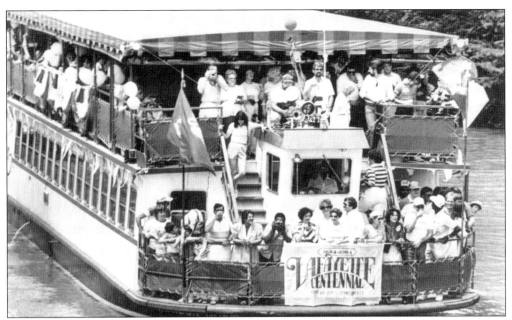

VERMILION QUEEN. During the 1980s, the *Vermilion Queen* cruised the waters of the Vermilion River as it flowed through Lafayette, offering daily tours, weekend dinner cruises, and private charters. The city built a docking facility for the boat adjacent to the Pinhook Bridge, which had to be raised to allow the boat to pass upstream. Here a large party celebrates the city of Lafayette's centennial in 1984.

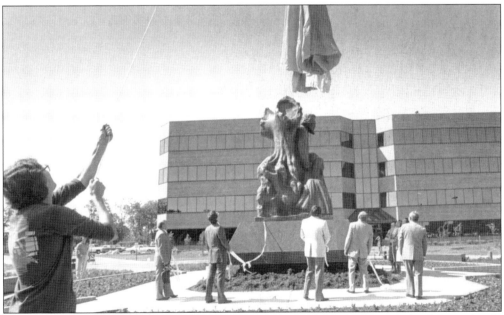

LONGFELLOW MONUMENT. As part of the centennial celebration in 1984, the Saloom family dedicated this monument to Henry Wadsworth Longfellow, author of the poem *Evangeline*, in memory of Mrs. Kaliste Saloom Sr., the former Asma Boustany. The statue by George Rodrigue shows the reunion of Evangeline and Gabriel under the protective gaze of the poet. It stands in front of the Saloom office park on Kaliste Saloom Road. (*Advertiser.*)

HERBERT HEYMANN. The son of Maurice Heymann was a businessman, civic leader, and philanthropist in his own right. Herbert helped develop the Oil Center, then later redeveloped it as retail and office space. He led campaigns to build the auditorium, the Cajundome, and several museums; was a leader in many charitable fund-raising organizations; and actively supported youth sports programs. In private, his generosity was equally boundless.

ACADIANA OPEN CHANNEL. Since cable television service came to Lafayette, Acadiana Open Channel (AOC) has offered public access television for Acadiana. AOC loans video equipment to local individuals or groups and trains them in its use. Community members, schools, local government, and nonprofit organizations provide the programming. Here Carla Thomas, the Lafayette Parish School Board's media center coordinator, films students at Paul Breaux Middle School performing in a play. (*Advertiser;* photograph by P. C. Piazza.)

BAYOU VERMILION DISTRICT. Levees around the Atchafalaya Basin after the 1927 flood cut off the flow of fresh water to the Vermilion River, and it became one of the most polluted rivers in America. In 1984, the state legislature created the Bayou Vermilion District (BVD), funded by a parish-wide property tax, to improve the water quality and promote recreational use of the river. The BVD clears the river of trash and debris, monitors the water levels and quality, and promotes its value for recreation. Shown above is one of the boat landings the BVD constructed on the river. Below are participants in the 1989 Bayou Bash, a festival held to highlight the river's potential as a recreational resource. (*Advertiser.*)

113

ACADIANA FOOD BANK. First organized in 1985 by Acadiana Bottling Company president Larry Smith, Acadiana Food Bank collects donations of nonperishable foodstuffs to supply food banks, homeless shelters, and meal programs for the poor in the Acadiana region. Collection baskets in grocery stores receive donations throughout the year, and food drives at holiday times gather more supplies. Pictured from left to right are Larry Smith, Marcelle Citron, and Karen Daigle. (*Advertiser.*)

STREET DANCE. Cajun music and Zydeco are best enjoyed from the dance floor. Traditionally Cajuns or Creoles in rural areas held dances called fais-do-dos where the whole community would gather to dance and socialize. Today the music is enjoyed in dance halls and at festivals. Here a group of dancers enjoy a performance on a particularly balmy Mardi Gras in 1982. (*Advertiser.*)

BELIZAIRE THE CAJUN. In 1986, filmmaker Glen Pitre filmed his independent movie *Belizaire the Cajun* in and around Lafayette, particularly at Acadian Village. The movie depicted the vigilante movement of 1859 from the point of view of their Cajun victims. Armand Assante starred as Belizaire, a clever healer and con man who tried to protect his people from the vigilantes and nearly was hanged for his efforts. Gail Youngs played the girl he loved, who was also the common-law wife of one of the vigilantes. Local residents worked as extras in the film, and Michael Doucet and Beausoleil provided the music. At right is Armand Assante as Belizaire. Below, a group of Cajuns discuss leaving for Texas to get away from the vigilantes. (Above, Michael Caffery for Cote Blanche Productions; below, *Advertiser*.)

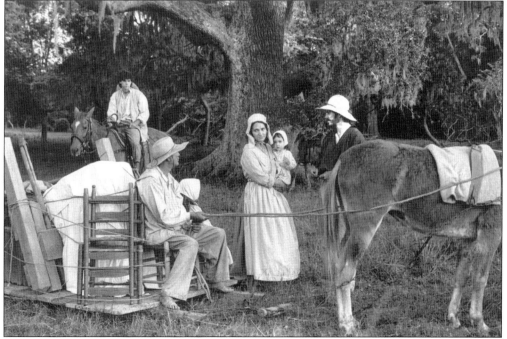

GEORGE RODRIGUE. Cajun artist George Rodrigue opened his studio in Lafayette in the 1970s, specializing in paintings of Cajun people and traditions, often in front of a large oak tree. He is best known for his Blue Dog series, begun in 1984 when he painted a loup-garou for a book of Cajun ghost stories. More recently, his work has included abstract representations of hurricanes and classical nudes. (*Advertiser.*)

I BELIEVE IN LAFAYETTE. As the oil industry collapsed in the mid-1980s, the Greater Lafayette Chamber of Commerce launched a campaign to promote a positive attitude about Lafayette's future. Lapel buttons, bumper stickers, window signs, and T-shirts proclaimed "I believe in Lafayette." From left to right are Phyllis Mouton, 1986 chamber president; Newton Elberson, owner of US T-Shirts; and Gene Fortier, 1987 chamber president. (*Advertiser.*)

Six

LAFAYETTE TODAY

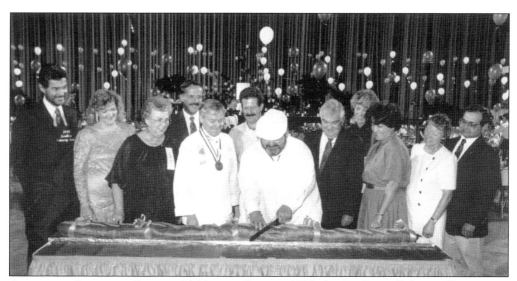

ACADIANA CULINARY CLASSIC. Held annually since 1985, the Acadiana Culinary Classic gives chefs from around Louisiana an opportunity to showcase their talents and creativity. The show traditionally opens with the slicing of a loaf of French bread, shown here with chef Paul Prudhomme in 1989, and includes cooking demonstrations and competitions. The show originally benefited the Louisiana Hemophilia Foundation; more recently it has supported Stuller Place. (*Advertiser.*)

BACH LUNCH CONCERTS. For 20 years, the Lafayette Natural History Museum and Planetarium has sponsored a series of free outdoor concerts on Fridays at noon. Different musicians perform each week in a range of popular styles, while local restaurants provide box lunches at a nominal cost. Originally held on the grounds of the museum near Girard Park, the concerts now take place in Parc Sans Souci. (*Advertiser.*)

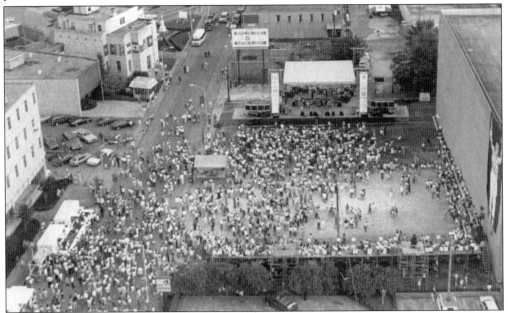

FESTIVAL INTERNATIONAL DE LOUISIANE. This annual visual and performing arts festival celebrates the cultural heritage of South Louisiana and its connection with French-speaking countries around the world. Held annually since 1987, it is the largest free outdoor Francophone event in the United States. Events include a wide range of concerts, dance and theater performances, art exhibits, cultural workshops, and cooking demonstrations. (*Advertiser;* photograph by P. C. Piazza.)

CLEANING GRAVES. Among the traditions that remain from earlier times is the custom of cleaning the tombs of family members and decorating them for the feast of All Saints' Day. Then on that day, November 1, family members visit the tombs to pray and to gossip with others on the same errand. Here a woman cleans a tombstone in St. John's Cemetery, the oldest cemetery in Lafayette. (*Advertiser.*)

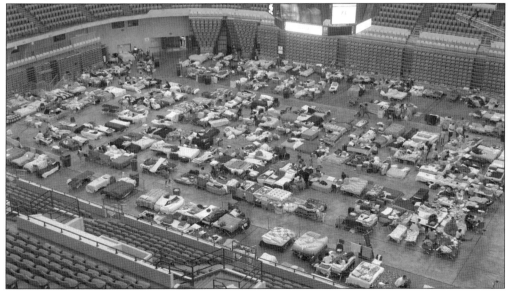

HURRICANE EVACUEES IN THE CAJUNDOME, 2005. After Hurricanes Katrina and Rita destroyed much of coastal Louisiana, the people of Lafayette rushed to help the victims of the storms. Local agencies, civic organizations, and individuals collected supplies and funds and donated countless hours of time. The Cajundome was the first stop for many New Orleans evacuees en route to Houston, and it served as a shelter for nearly two months. (Philip Gould.)

GATEWAY LAFAYETTE. In 1990, the Tourist Information Center moved to a new location in the median of Evangeline Thruway near the intersection of Interstates 10 and 49. Supported by the Greater Lafayette Chamber of Commerce and many other community groups, the 96-acre park also included an alligator pond, a sensory garden for the blind, an agricultural demonstration area, and acres of wildflowers and other native plants. (Sarah Life for Lafayette Convention and Visitors Commission.)

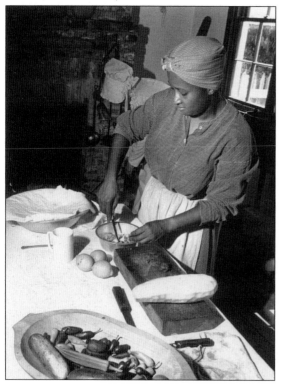

VERMILIONVILLE HERITAGE AND FOLKLIFE PARK. In 1990, the Lafayette Parish Bayou Vermilion District opened Vermilionville, a living history museum re-creating life in Acadiana between 1765 and 1890. The historic village, located on the Vermilion River near Beaver Park, contains 18 buildings, six of them authentic historic homes. Costumed interpreters demonstrate traditional crafts and music. Here an interpreter demonstrates the differences between Cajun and Creole cooking. (*Advertiser.*)

C.R.E.O.L.E., Inc. Not every French speaker in Acadiana is a Cajun. African Americans have formed C.R.E.O.L.E., Inc. (Culture, Resource, and Education of Linguistic Enrichment) to highlight the traditions of people of African descent whose cultural roots include French, Spanish, Native American, and other ethnic influences. Pictured in 1990 are Vice Pres. Herbert Wiltz, Pres. Paul Cluse, and Treasurer John Broussard with city council member Helen Bellamy. (*Advertiser.*)

University of Louisiana at Lafayette. In 1999, as it began its centennial celebration, the University of Southwestern Louisiana changed its name to the University of Louisiana at Lafayette. With a student body of 16,500 and a faculty of nearly 550, it offers degrees in some 60 baccalaureate, 27 master's, and eight doctoral fields. The main campus occupies over 150 acres, with the athletic campus located a short distance away. (UL Lafayette.)

PELICANS ON PARADE. In 2001, the Acadiana Arts Council and the Lafayette Parish School System sponsored the largest public art exhibit ever held in Acadiana. Local sculptor David Fox and his students at W. D. Smith Career Center designed the fiberglass statues. Artists throughout the state submitted designs for decorating them, and more than 70 were produced and put on display in Lafayette and surrounding communities.

DOWNTOWN ALIVE! In an effort to bring people back into the downtown area, the Downtown Development Authority began sponsoring a series of street dances on Friday afternoons. Streets were closed to traffic and a stage set up for the band to perform. Street vendors offered food and beverages. Today the concerts are held in one of the two public parks that have been opened downtown. (*Advertiser.*)

ACADIANA FARMERS MARKET. Who doesn't prefer fresh, locally grown fruits and vegetables? Gardening is almost a year-round activity in Lafayette's mild climate, and for many years, local gardeners and truck farmers sold their surplus produce at the Acadiana Farmers Market, located in a vacant lot on the corner of Foreman and Marie Antoinette near Lafayette High School. (*Advertiser*; photograph by Ron Ortego.)

LOUISIANA ICEGATORS. Ice hockey was an improbable success when the Louisiana IceGators, a member of the East Coast Hockey League, were formed in 1995. A removable ice rink was installed in the Cajundome for the team's home games. The IceGators shattered league attendance records and dominated league standings but never won a championship. Attendance fell off as ticket prices rose, and the team folded in 2005.

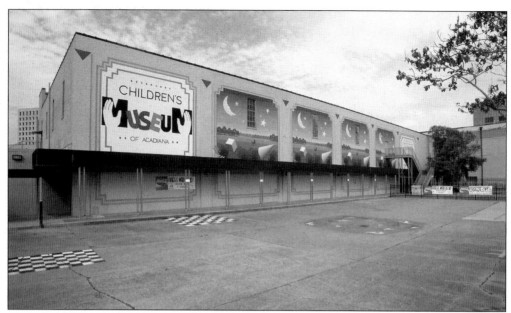

CHILDREN'S MUSEUM OF ACADIANA. Inspired by a similar museum in New Orleans, three women founded a children's museum in Lafayette. In 1993, they purchased the old Heymann Food Center building downtown and renovated it with help from local civic clubs, restaurants, businesses, and construction firms. The museum opened in 1996 with exhibits, including a bank, grocery store, television station, bubble station, ambulance, amphitheater, and activity centers. (Kent Hutslar for Lafayette Convention and Visitors Commission.)

LAFAYETTE NATURAL HISTORY MUSEUM. In 2002, the old Heymann Department Store building downtown was completely gutted and rebuilt to house the Natural History Museum. The new location provides larger spaces for exhibits and the museum adds to the downtown area's new role as a cultural center. Art galleries, museums, restaurants, clubs, festivals, and public art are located within the area. (Sarah Life for Lafayette Convention and Visitors Commission.)

University Art Museum. The building on the right was designed in the Colonial Louisiana plantation style by noted architect A. Hays Town, who grew up in Lafayette. It was funded by community donations and constructed by the University of Southwestern Louisiana Foundation on land donated by Maurice Heymann. It opened in 1968 and originally housed the foundation's collection of Louisiana art with additional space for traveling exhibitions. The building behind it was constructed in 2004, funded in large part by a generous gift from Paul and Lula Hilliard, for whom it is named. A state-of-the-art facility, it contains 11,000 square feet of exhibit space, plus storage and conservation space. The new building's mirrored wall reflects the older structure, uniting the two. (Sarah Life for Lafayette Convention and Visitors Commission.)

CLERK OF COURT PHOTOGRAPH COLLECTION. Dan Guilliot, clerk of court for Lafayette Parish from 1972 until his death in 1999, requested copies of old photographs to put on permanent display in the clerk's office. Lafayette citizens responded enthusiastically, and the resulting collection now fills the walls and display cases with images of the parish's people, buildings, and activities, complementing the written records that have always been kept there. (*Advertiser.*)

BIBLIOGRAPHY

Anders, Quintilla Morgan. *Some Early Families of Lafayette, Louisiana*. Lafayette, LA: Sans Souci Bookstore, 1969.

Barde, Alexandre. *The Vigilante Committees of the Attakapas*. Trans. by Henrietta Guilbeau Rogers, annotated and edited by David C. Edmonds and Dennis Gibson. Lafayette, LA: Acadiana Press, 1981.

Brasseaux, Carl A. *Lafayette: Where Yesterday Meets Tomorrow*. Chatsworth, CA: Windsor Publications, 1990.

Conrad, Glenn R., ed. *A Dictionary of Louisiana Biography*. New Orleans: Louisiana Historical Association in cooperation with the Center for Louisiana Studies, University of Southwestern Louisiana, 1988, 1999.

Daily Advertiser. Lafayette, LA: 1914–2007.

Daughters of the American Revolution, Louisiana Society, Galvez Chapter, Lafayette. *History of Institutions and Organizations in Lafayette, Louisiana*. Unpublished manuscript, 1951.

Dismukes, James Philip. *The Center: a History of the Development of Lafayette, Louisiana*. Lafayette, LA: City of Lafayette?, 1972.

Griffin, Harry Lewis. *The Attakapas Country: a History of Lafayette Parish, Louisiana*. New Orleans: Pelican Publishing Company, 1959.

Guillot, O. C. *Images de Lafayette: a Pictorial History*. Lafayette, LA: self-published, 1992, 1993.

Lafayette Parish, Louisiana, Regional Planning Commission. *Lafayette Parish Historical Sites Inventory*. Lafayette, LA: self-published, 1976.

Lafayette Remembered: the Centennial Album, 1884–1984. Lafayette, LA: The Advertiser, 1984.

Mamalakis, Mario. *If They Could Talk!: Acadiana's Buildings and Their Biographies*. Lafayette, LA: Lafayette Centennial Commission, 1983.

Perrin, William Henry. *Southwest Louisiana, Biographical and Historical*. Baton Rouge, LA: Claitor's Publishing Division, 1971.

Valentine, Orpha. *Lafayette: Its Past, People and Progress*. Baton Rouge, LA: Moran, 1980.

ACROSS AMERICA, PEOPLE ARE DISCOVERING SOMETHING WONDERFUL. *THEIR HERITAGE.*

Arcadia Publishing is the leading local history publisher in the United States. With more than 3,000 titles in print and hundreds of new titles released every year, Arcadia has extensive specialized experience chronicling the history of communities and celebrating America's hidden stories, bringing to life the people, places, and events from the past. To discover the history of other communities across the nation, please visit:

www.arcadiapublishing.com

Customized search tools allow you to find regional history books about the town where you grew up, the cities where your friends and family live, the town where your parents met, or even that retirement spot you've been dreaming about.